OHIO
TRAIN
DISASTERS

OHIO
TRAIN
DISASTERS

JANE ANN TURZILLO

THE
History
PRESS

Published by The History Press
Charleston, SC 29403
www.historypress.net

Copyright © 2014 by Jane Ann Turzillo
All rights reserved

First published 2014

Manufactured in the United States

ISBN 978.1.62619.258.4

For Jack (1976–2010), because we miss you so much.

CONTENTS

ACKNOWLEDGEMENTS

I am delighted to have written *Ohio Train Disasters*, my third book, for The History Press. There would be no book without the help of my family, friends and many others. This page is where I get to acknowledge their assistance and to thank them.

First and foremost, I would like to thank my editor, Greg Dumais, for his foresight and patience. This book was his idea.

What is a train book without an engineer? I was lucky enough to have help from Rich Weller, retired engineer and mechanic for the Indiana & Ohio Railroad and current volunteer engineer and mechanic for the Whitewater Valley Railroad. His knowledge is boundless.

Family friend Deb Murphy and her Ashtabula friends gave me a heads-up on where to go in Ashtabula and what photos to take for the Ashtabula train wreck (No. 5 Is in the Creek!). Thank you, Cindy Wagner, descendant of Nellie Fay Daubenmire (The Middletown Tragedy), for giving me three photos for the book.

No book having to do with history could be written without the help of librarians, archivists and historical society curators and volunteers. They are the stars. All of the people listed here deserve a huge thanks. They provided me with research and photos. They are: George Adams, director of the G.W. Adams Educational Center, Prospect Place; Kimberly Barth, director of Photography & Graphics, *Akron Beacon Journal*; Nancy Arnold, curator, Jennie Munger Gregory Museum and Research Room; Cheryl Ashton, Amherst Library; Kristin Choiffi, reference specialist, Amherst Library; Laura

ACKNOWLEDGEMENTS

Cramblet, library director, Bellaire Public Library; Liz Cross, Cuyahoga Falls Historical Society; Kori Fields, Conneaut Railroad Museum; Jennifer Fording, MA, MLIS, local history librarian, Harris-Elmore Public Library; Sandy Grigsby, reference clerk, Chillicothe and Ross County Library; Phil Haas, director of archives, Diocese of Cleveland; Donna Hudacek, Scipio Republic Area Historical Society; Judy James, Special Collections, Akron-Summit County Public Library; Pat Kelly, photo archivist, National Baseball Hall of Fame Library, Cooperstown, New York; Kristina Lininger, assistant librarian, Upper Sandusky Community Library; Ronald I. Marvin Jr., director, Wyandot County Historical Society and Museum; Rachel Mathie, Local History/Genealogy, Loudonville Public Library; Gwen Mayer, archivist, Hudson Library & Historical Society; Pat Medert, Ross County Historical Society; Ann McRoden Mensch, professional genealogist; Irene Metz, Cuyahoga Falls Historical Society; Donna Rumpler, administrative assistant, Amherst Historical Society; Cathy Reid, Clark County Public Library; Dierdre Root, Middletown Library; Mark Steinmetz, Seneca County Museum; Mitch Taylor, Pioneer & Historical Society of Muskingum County; Lisa Uhrig, Ross County Historical Society; James A. Willis, author and founder-director of the Ghosts of Ohio.

This book would not have been possible without those period journalists whose bylines never appeared at the tops of the newspaper stories they wrote.

I owe a huge thanks to my author friend Wendy Koile, who helped with the research and scanned some of the hard-to-find photos. She is a great sounding board, as well as having a wonderful sense of humor.

Two of the most important people to my writing career are my beta readers. In addition to checking my spelling and punctuation, they give me confidence and are great mentors. Both former professors of English at Kent State University and fine authors themselves, they are my sister, Mary Turzillo, PhD, and my friend and neighbor Marilyn Seguin.

I also want to thank my Northeast Ohio Sisters in Crime for their motivation.

And of course, thank you to John-Paul, Nicholas and Nathan just for being who you are. Love you.

I hope I have not forgotten anyone. If I did, it was not intentional.

INTRODUCTION

My paternal grandmother, Ugenia Monaco Turzillo, lived on Depot Street across from the railroad tracks and the little old Cherry Creek, New York station. When the big black goliaths rumbled down the track and passed her house, the dishes and glasses in the cupboards shook until I was sure some of them would jitterbug off the shelves and smash on the floor. Still, I loved sitting on the porch of her tiny shotgun-style house and watching the trains roll by. Even now, the wail of a locomotive's whistle is a pleasant, if not melancholy, sound.

It was in this little town that my dad, Lee Turzillo, as a very young man, hopped on the back of a slow-moving freight train for a bigger city and the dream of a new and more prosperous life. He told my sister and me this story many times. I often thought that if it had not been for trains, he might not have realized his potential at becoming one of the foremost authorities on concrete in the world during the 1950s, '60s and '70s. Ironically, part of his career was devoted to building, restoring and repairing railroad bridges.

Just as the railroads played a role in my family's history, they were central in developing the Buckeye State. By the mid-1800s, Ohio was home to a network of railroad systems that transported wares and goods throughout the country. Passenger trains carried travelers from one station to the next or took them great distances. Cities and towns sprang up all along the iron rails. The railroad connected our state to the rest of the nation.

While Ohioans and their merchandise rode the rails, so did death and destruction. Train travel was not always as safe as it is today, as evidenced

in the twelve chapters offered in this book. Accidents happened because of human error or negligence. Sometimes bridges were not up to the weight of the huge iron beasts. Still other disasters were caused by derailment.

Fire was the number one killer during an accident. Coaches were heated in the winter by stoves and lit after dark by oil lanterns. When a train wrecked, the stoves and lanterns tipped over. Flames fueled by oil from the lamps and dry wood from the cars' construction would immediately engulf everything, leaving most passengers to perish. The wrecks in Ashtabula, Cuyahoga Falls and Republic are just a few examples.

Steam pouring out of a wrecked engine was maybe even a more horrific killer, as it scalded people to death. The disaster in Dresden is a heartbreaking example.

Other accidents produced mangled bodies—some unidentified to this day—from twisted metal, sharp glass and splintered wood. They left widows and orphans behind and made some men and women heroes.

Here are twelve stories of trainmen, victims and the behemoth locomotives that helped to build the Buckeye State and our lives.

Chapter 1
THE MIDDLETOWN TRAGEDY

There were no celebrations in Middletown, Ohio, on Monday, the Fourth of July in 1910. Instead, a head-on crash between a passenger train and freight train, three hundred yards from the town's depot, stole the Independence Day revelry, as well as twenty-four lives. Thirty-six people were badly injured.

Freight train No. 90 was owned by the Cincinnati, Hamilton & Dayton (CH&D) Railroad. Loaded with lumber, it was headed north on its own mainline, pulling gondola cars, flat cars and boxcars.

The passenger train was the New York–Cincinnati Flyer, No. 26, one of the fastest and most elegantly appointed passenger trains of the day. It ran between New York and Cincinnati. Owned by the Cleveland, Cincinnati, Chicago and St. Louis (Big Four) Railroad, it was rolling south carrying passengers from Cleveland to Cincinnati on the CH&D tracks. Ordinarily, it would have been traveling on its own track, but when it arrived at Dayton, its crew received orders to detour onto the CH&D road. An earlier accident at Genoa several miles north of Middletown had closed off its usual route. It picked up a CH&D pilot engineer, William Wald, at that point.

Harry Hamel, the freight train's engineer, was just pulling out of Middletown when he received his orders to make Poasttown three miles north, take a siding there and give the passenger train a clear track. He realized that he had only seven minutes to do that. He knew he could not make it to Poasttown in time. Instead of taking the chance, he attempted to back his train into the West Middletown siding. But there was not time.

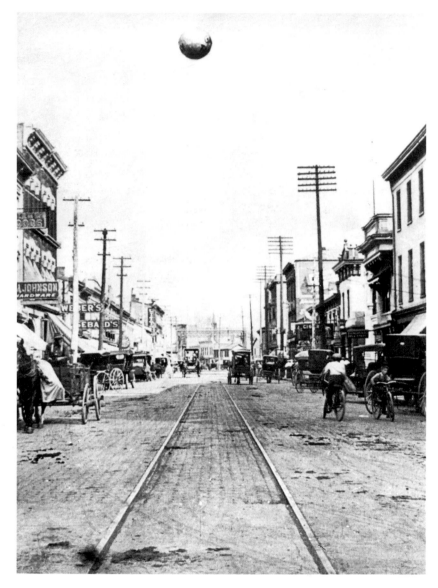

Third Street in 1910, today's Central Avenue. The ball in the sky was an advertising device. *Courtesy of the MidPointe Library System, Middletown, Ohio.*

At 1:02 p.m., the passenger train came roaring around the corner doing fifty to sixty miles per hour and slammed head on into the freight train. The impact was so great that the engines were embedded into one twisted hulk of iron and metal and the sound thundered for miles around.

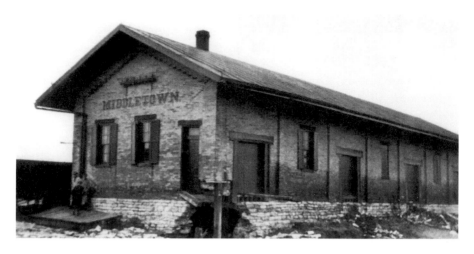

West Middletown depot. *Courtesy of the MidPointe Library System, Middletown, Ohio.*

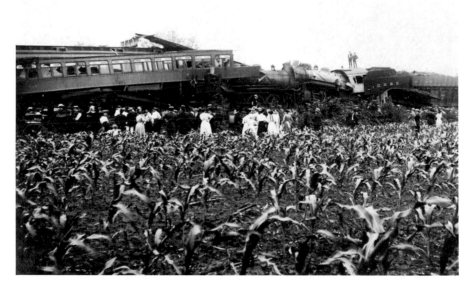

The CH&D and New York–Cincinnati Flyer's engines embedded into each other. *Courtesy of the MidPointe Library System, Middletown, Ohio.*

When the engines plowed into each other, one of them rammed through the combination baggage car and smoker. The front end of the day coach, or ladies' car, reserved for women and their children, was crushed. It and the

smoker/baggage car were hurled across the track, one landing on top of the other. Then they both rolled ten feet down the embankment into a cornfield. Every seat in the coach was ripped from its fastenings. The five passengers riding in the smoker/baggage car all met their deaths. Three women died, as did some of the men in the ladies' car. Many victims were pinned under the wreckage.

The dining car was ground into tinder. Nearly all of the fifteen passengers riding in that car perished. Those who were not killed were gravely injured.

The Flyer was pulling three Pullman sleepers. The first, named the "Duvas," was a complete wreck, with the forward vestibule being reduced to kindling. The sleepers were all derailed. Although some of the passengers in the sleepers were merely shaken up, others were slashed by flying glass. A number of victims on the sleepers received broken bones and bruises from being hit by or pinned under heavy debris. But they all escaped death and life-threatening injuries.

The Flyer's engineer, Peter Jennings, and its fireman, W.P. Lamb, jumped from the cab seconds before the crash. Both men suffered internal injuries. Jennings was scalded and later lost one of his legs. The two trainmen lived in Delaware, Ohio. The CH&D pilot engineer, Wald, and conductor, Tom Mollony, emerged from the wreck unscathed, but the brakeman, Frank Golden, was killed. The rest of the crew denied jumping from the impending disaster.

Freight train engineer Hamel, of Cincinnati, and his fireman, Vernon Wallace, of Lima, saw the crash coming and leaped from their locomotive just in time to save their lives. Neither sustained any injuries.

Any of the crew and passengers who had not been harmed began rescue efforts immediately. Faced with injured and dead pinned under the wreckage or lying along the track, they worked feverishly. Within a few minutes, eleven bodies had been recovered.

In less an hour, word spread of the accident, and a crowd began to gather. During the rescue efforts, it swelled to about two thousand people. Automobiles and horses clogged the main roads in Middletown. Standing on parts of the wreck, the spectators ignored the danger of getting too close and hampered the recovery.

One of the first critically injured to be taken out of the wreck was a young woman named Fay N. Daubenmire, who had boarded the train in her hometown of Pleasantville, Ohio, at 8:29 that morning. The eldest daughter of Peter and Mary Daubenmire, she was twenty-two years old. A highly respected and cultured young lady, she taught in the Mount Gilead schools.

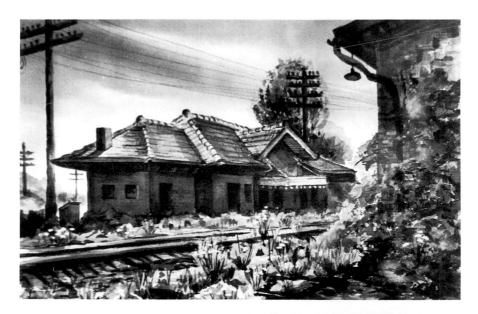

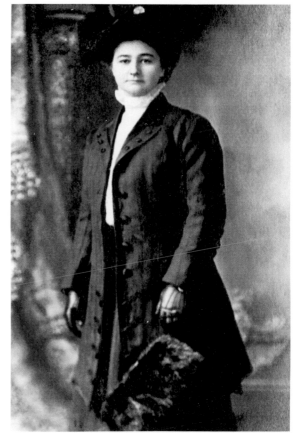

Above: *The Depot* by Mary Louise Skinner. *Courtesy of the MidPointe Library System, Middletown, Ohio.*

Right: Fay N. Daubenmire dressed in what looks like her traveling clothes. *Courtesy of Cindy Wagner.*

Like so many young women, Fay had great hopes of a career on the stage and was on her way to Cincinnati to take special training in elocution. To this end, she was to have met the famed actress Miss Jennie Mannheimer, who was the director of the Cincinnati School of Expression. The actress had secured a room for Fay in Cincinnati on June Street, where she could live while she studied for her stage career.

Mrs. George Huff and Mrs. F.W. Weickel carried her broken and bleeding body on boards to a humble little restaurant near the accident. One of the workmen folded his jacket and slid it under her head. The women tried to find out her name, but her throat and chest had been seared by steam and her vocal chords were paralyzed. Weakly, she signed her first name, *F-A-Y*, and then her blistered hands dropped to her sides. The women encouraged her. She gave a faint smile and again feebly raised her hands to sign her last name. She lived for about an hour after the accident. The Reverend T.S. Gerhold, pastor of the Evangelical Church of Middletown, gave comfort in her last moments.

An account in the *Cincinnati Times Star* was especially heartbreaking. It read in part:

> *Heads bared and bowed as the pastor knelt beside the dying woman, and lifted his hands and his voice in her behalf to heaven. With her fast ebbing strength, she put forth her hands and touched the arm of the minister. Her fingers clutched it and feebly pressed it to show that she understood. She raised her eyes and as the last words were said, her lips were seen to whisper the word that could not be heard—Amen. The eyes closed, and she was gone to her maker.*

Fay's final resting place is in Hampson Cemetery in Pleasantville.

Five young men, all between seventeen and nineteen years old, had high hopes of "seeing the countryside" when they jumped aboard the fast passenger train at Dayton that Monday morning. By afternoon, four of them were confirmed dead, and the fifth was missing.

Brothers Tom and William Dunleavy set out for an adventure with pals Richard Van Horne, George H. Frohle and Edward Cain. As the Flyer was pulling out of the station, the daredevils jumped between the tender and the baggage car to "ride the blinds." They chose to ride one of the most dangerous positions on the train—hiding in the crossover diaphragms or in the end doors of the baggage car, out of sight from someone on the ground. Four of their bodies were found in the adjacent cornfield. Cain was missing at first.

When their friends from Dayton heard of the wreck, they were certain the five had been among those killed because of where they were riding. The Dayton friends made the trip to Middletown to identify their friends. They found the Dunleavy brothers together, laid out on boards at the undertaking establishment. What remained of Van Horne's and Frohle's bodies was found at another makeshift morgue. The body of Edward Cain, who had worked as a chef, was found later and identified by his friends.

Another body was identified as William Anzinger. He was to have been married soon to Edna Gano. They were both from Springfield.

Fay N. Daubenmire's resting place in Pleasantville. *Courtesy of Cindy Wagner.*

Only one person was due to detrain at Middletown. She was an actress named Mrs. Edward Lloyd and half of the vaudeville team Lloyd and St. Clair. She was coming to Middletown from New London, Ohio, for a vaudeville engagement. She was scalded in the wreck and pinned between timbers and died in a hospital in Dayton. She was from New York.

Lester Browdy, a newsboy from Cleveland, gave the *Butler County Democrat* his account of the wreck. He was riding in the smoking car, where he and five other men were having a spirited conversation about the next day's heavyweight championship fight between James J. Jeffries and John Arthur Johnson in Reno, Nevada. When the trains collided, "it felt like the air was all gone," Browdy said. "Then there was a grind and we heard the brakes put on in an attempt to stop the train." Two of the other men riding with Browdy in the smoking car were thrown up at

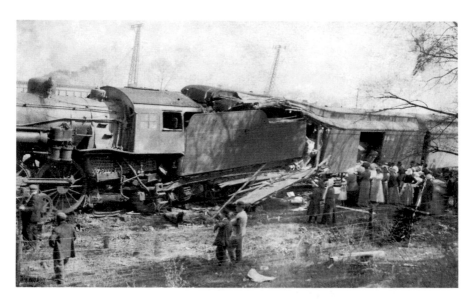

The engine of the New York–Cincinnati Flyer, No. 26. *Courtesy of the MidPointe Library System, Middletown, Ohio.*

least fifteen feet in the air and then across the freight train. They landed in a cornfield.

"I saved myself by hanging to a strap, for when the brakes went on I realized something was wrong," he said. The reporter could see that Browdy's hands were cut up from shattered glass. "I looked up and found one of the men who had been laughing a minute before still sitting in his seat, but he was dead. The two other passengers were piled on top of each other."

By 4:30 that afternoon, the rescuers were joined by fire and police personnel, doctors, undertakers and some of Middletown's residents. At that point, thirty-one bodies had been pulled from the wreck, but they knew there were more buried within the steel tomb.

Wrecking cars arrived in the late afternoon and began clearing the wreckage, but the rescue effort continued well into the next day. Very early the next morning, near the end of the recovery as the cranes were removing the last pieces of the ladies' coach, they saw an arm sticking out of the debris. In hopes of finding the victim alive, they worked fast. There under the splintered wood and twisted metal, they uncovered a young boy who was gravely injured. Huddled above him was his mother, who had obviously tried to shield him with her own body. The collision had turned her into a shapeless mass. "Poor Mother, she's dead,"

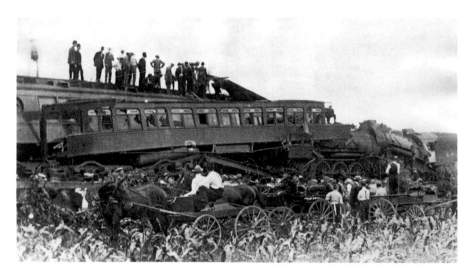

Rescuers and curiosity seekers at the train wreck in Middletown. *Courtesy of the MidPointe Library System, Middletown, Ohio.*

sobbed the boy, who gave his age as seven and his name as Samuel Wayne Garrigus.

He was riding the train with his mother, forty-four-year-old Lydia, and his father, forty-two-year-old Ared. As prominent members of the Friends church, his parents were instrumental in establishing several churches in Southwestern Ohio and Newport, Kentucky. They were living in Columbus at the time of the crash. "Please try to find my papa. I don't know where he is," the boy said.

It was obvious that the child's arms and ribs were broken, so the rescue squad swept him away to an ambulance. "Oh no, don't mind me," the boy begged. "Let me go for awhile and find my father. Maybe he don't know that mother is gone." No one had the heart to tell him that his father had died the night before in a hospital in Dayton. His mother's body was identified later that day.

Young Samuel Garrigus was taken to Miami Valley Hospital in Dayton, where doctors found his injuries to be far more serious than first thought. He had an arm and a leg amputated, but he also had internal injuries. His doctors did what they could for him, but they did not think he would live.

A day later, a seven-month-old baby girl was found in the same cornfield as the men riding with Browdy. The child had most likely been hurled from the wreck the day prior to her discovery.

The CH&D depot at West Middletown. *Courtesy of the MidPointe Library System, Middletown, Ohio.*

Luckily, the baby was uninjured but probably hungry and thirsty. There were no reports of anyone coming forward to claim her.

The Middletown area had no hospital, so its residents opened their homes to help care for some of the injured. Every ambulance in the area responded to transport the victims to the Elks Temple, physicians' offices, area homes and police headquarters. The most serious cases were transported to hospitals in Dayton and Hamilton.

In spite of the curiosity seekers, the recovery effort was accomplished efficiently and fairly fast. Rathman & MacCoy, A.T. Wilson & Sons, J.D. Riggs and Bailey & Bachman, the four undertaking establishments in Middletown, received and cared for the dead. Some of the bodies were tangled together, and some were mangled beyond recognition. One young man, who looked to be about twenty-five, was decapitated. His head was found a foot away from his body. Terror was frozen on the faces of some of the dead, who apparently knew what was happening to them. All of the bodies were identified.

John A. Burnett, coroner of Butler County, along with the officials of both railroads, began to probe the accident for a cause.

E.A. Gould, general manager of the CH&D Railroad, was reticent to place blame. Instead he called it a "lap" in orders. However, when Pilot Engineer Wald of the passenger Flyer claimed the train dispatcher was at fault, Gould did not deny it.

"The engineer of the freight train [Hamel] showed me order No. 60 supposedly issued after our train left Dayton and to have been handed to us at Carlisle," Wald said. "This gave the freight until 1:07 p.m. to make the sidling at Poasttown."

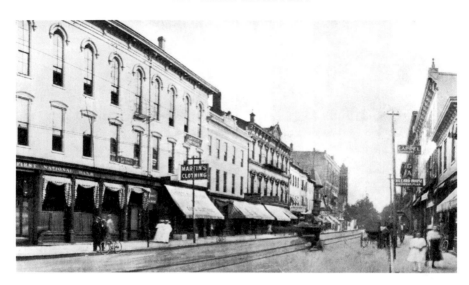

Above: Main and Third Streets in 1910 Middletown. Interurban tracks provided transportation to Dayton, Hamilton and Cincinnati. *Courtesy of the MidPointe Library System, Middletown, Ohio.*

Right: Looking west at West Middletown. Many residents took the injured and dying into their homes. *Courtesy of the MidPointe Library System, Middletown, Ohio.*

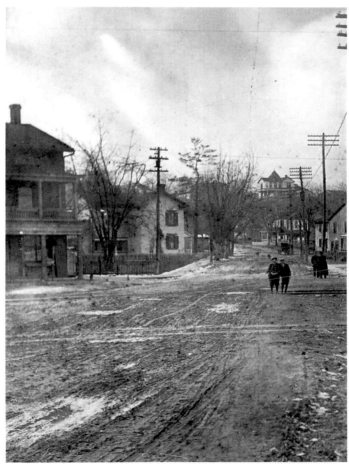

Fay N. Daubenmire. *Courtesy of Cindy Wagner.*

Wald complained that the dispatcher revoked the order, so it was not delivered to his train crew. "But he failed to revoke the same order issued to the freight." The Flyer was made up after leaving Dayton and it brought them to the Poasttown siding earlier than 1:07 p.m.

"We had no warning of anything in the way and supposed we had a clear line," he said, showing four orders, none of which indicated that his train was to meet any other train between Dayton and Cincinnati, let alone Poasttown. "These orders were all I had to guide me on that day."

Butler finally attributed the wreck to "carelessness and negligence." He placed blame on the CH&D chief dispatcher, whose last name was Smith. The dispatcher readily admitted his part in it, but he claimed the Flyer's speed contributed to the accident. The dispatcher was fired.

Butler also placed blame on the freight crew and the CH&D pilot engineer William Wald on board the passenger train.

In the end, the accident became known as the worst train accident in Butler County's history. It was one of the disasters that led to building of the first hospital in Middletown.

Chapter 2
DEATH VEILED IN FOG

The sounds of metal crashing against metal and cracking wood punched through a dense fog, jarring awake the citizens of Amherst in the pre-dawn hours of Wednesday, March 29, 1916. Minutes later, a second crash exploded over the town. After that, the sounds of hissing steam and human wails pierced the air.

The hellish noises were the result of three New York Central trains, called flyers for their speed and limited stops, colliding west of the switch tower near Milan Avenue and Lake Street. The trains involved in the disaster were the first and second sections of passenger train No. 86, the Pittsburgh-Baltimore-Buffalo Limited, traveling east, and the Twentieth Century Limited passenger train No. 25 rolling in the opposite direction.

Train traffic was unusually heavy for a Tuesday night, March 28, so No. 86 had been split into two sections. The first section consisted of six Pullmans, a coach, a baggage car, a postal car and a club car. Pulled by engine 4871, its run was from Chicago to Pittsburgh that night with Conductor Frank Bunnell in charge and Engineer D.W. Leonard at the throttle. The train was so fast it could make the run from Chicago to Baltimore in thirteen hours and thirty-five minutes.

The second part of that train was also known as No. 86. Its locomotive, 4887, drew five Pullmans, three coaches, four baggage cars and an express car. John Keller was the conductor on this train. The engineer's last name was Hess, but four different first names (Herbert, Herman, John and Martin) turned up in newspapers. The Interstate Commerce Commission report gave no first name.

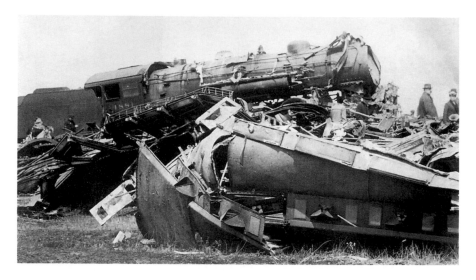

Engine 4887 pulled the second section of Pittsburgh-Baltimore-Buffalo Limited No. 86. *Courtesy of the Amherst Historical Society.*

Some recounts claim the two trains were only a mile apart at some points during the night.

The Twentieth Century Limited, No. 25, was en route to Chicago from New York City. It consisted of six Pullmans, a club car and an observation car. C.C. Robinson was the engineer on locomotive 4813, and M.V. Burke was the conductor.

The first half of No. 86 left Toledo eight minutes late. The second half left that city twenty-one minutes late. The westbound Twentieth Century was four minutes behind schedule. All three were trying to make up time.

According to the Interstate Commerce Commission report, the trains were governed by a timetable and an automatic block signal system, so they were not controlled by the tower man, Albert Ernst, as first thought. The signals were located on bracket poles at the side of the track. The first signal, two miles out, was most likely yellow, telling the second section train to slow down to thirty miles per hour and be prepared to stop before the next signal. The next signal was one mile out. It was red, but Engineman Hess apparently did not see it. A red light meant the engineer was supposed to stop and then proceed with care in case there was any track obstruction. As the train approached, both a visual and auditory signal was sent to the tower, which was one mile west of the Amherst station.

Leonard, the engineer on the first locomotive, approached the Amherst tower and could barely discern through the fog that signal S72 was in the

yellow caution position. He slowed the train and then ground it to a stop when he saw signal 40 west of Amherst tower in the red stop position. The flagman hopped off the train, lighted a five-minute red fusee flare and started for the back of the train to swing down the second train. The engineer blew the whistle, and the signal cleared. The flagman did not even have time to reach the back of the train, so he climbed back aboard. The engine slipped and stalled. The flagman again got off. This time, he heard the second section of No. 86 approaching. It sounded like it was using steam and was about a mile away. He ran for the rear of his train with a lantern and a lighted flare. Engineer Leonard backed up the engine to take up the slack, sometimes called the "slop," between the cars and then quickly put it in forward to get it moving again.

The first section had pulled only a few car lengths when the second section of 86 piled into it doing between fifty and sixty miles an hour. The goliath engine slammed into the steel coach of the first train with such impact that it raised the back end of the car and rammed it forward under the back of the club car. The club car was forced at right angles across the parallel westbound track. Forty passengers rode in that last car. Whether any of them were killed at that point was never known, but for certain, many were injured.

R.D. Turner was the fireman on the second section of 86 and also an Amherst resident. He later said that the fog was so thick he could not see fifty feet in front of his train. He did not know that the first section was close ahead of them when they piled into it.

Moments later, No. 25, which was working steam, came barreling out of the fog down the westbound track at seventy miles an hour and plowed into the wreckage obstructing the track in front of it. Leonard blew his engine whistle, but Engineer Robertson said he did not see the wreckage on the track in front him. His massive locomotive nearly cut the club car in half, pushing one end of it into the steel coach and destroying it. The engine rolled over on its side and continued sliding on the roadbed for approximately seven hundred feet, striking and overturning several of 86's cars that were in its path. It righted itself but ultimately turned over again, hissing steam escaping from leaks in the boiler.

The *Amherst Reporter* carried an interview with an Atlanta, Georgia man, T.M. Webb, who was a passenger on the first section of No. 86. He told the reporter it was 3:40 in the morning, although the trainmen put the time between 3:15 and 3:20. He was awake in the Pullman car, third from the end, when the first crash occurred.

An example of a train stove at the Amherst Historical Sandstone Village. *Photo by Jane Ann Turzillo.*

He said, "The first section of No. 86 had stopped for a few minutes and was just creeping along when the second section plowed into it." Webb said he thought the second section was traveling about forty miles an hour, but the train was actually running between fifty and sixty miles per hour.

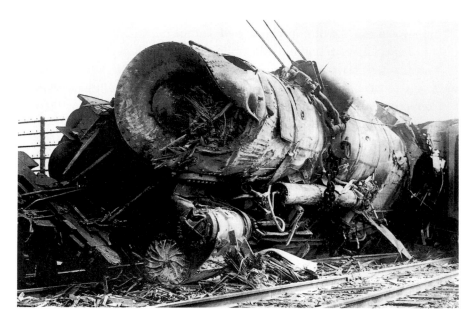

The collision of three fast passenger trains in Amherst resulted in twenty-seven deaths and forty-seven injuries. *Courtesy of the Amherst Historical Society.*

"The buffet car which was the last car of the train in our section and the day coach, the second to the last, were hurled onto the westbound track," he said.

Passenger Aaron DeRay of Pittsburgh was lying in a berth of the Toledo sleeper of the first section when the crash occurred. He was thrown from his berth into the one across the aisle, which was occupied by a woman. Neither was hurt.

Moments later, the Limited's behemoth engine careened into the wreckage. "Passengers had not had time to realize what had actually happened," he said. Whether anyone was killed as a result of the first crash he did not know, but he was certain some of the people who suffered injuries from that first wreck were killed during the second crash. "I counted at least ten dead and thirty injured and then gave up the task. It was an awful sight—limbs and portions of bodies strewn everywhere."

Another Cleveland passenger had been reading a magazine as he sat in the "death coach," as the last car on the first section of No. 86 became known. He recalled hearing four sharp blasts of the train's whistle right before the first crash, and then the lights went out. He was pinned under something, but he did not know what. Then the coach was hit a second time.

"It seemed to me like our coach opened like an umbrella." He was tossed out of the coach and found himself "rolling into a ditch in pitch blackness."

Felix Orman, associate editor of the *Outlook,* was on his way from New York to Chicago. He was stunned when he was thrown from his berth. "I recovered in a second or two and I picked up my clothes and crawled out of a window. I dressed outside," he said.

Some of the passengers who climbed out of the trains began to help. They found a massive amount of debris scattered for half a mile, and the tracks were torn up for several hundred yards. Mutilated souls cried out. One gentleman from Pittsburgh said he watched as a woman died in the wreckage before she could be extricated. He told of a man whose arms had been torn from their sockets.

Passenger Webb claimed that it took two hours before the injured received any medical attention, but Amherst mayor E.E. Foster was quick to arrive at the scene. He rang the bell at the town hall to summon help. The town's firemen, half-clad townsmen, railroad workers and farmers who lived in the area were the first responders.

They were faced with the gory scene of the injured and dead, some of them still adhering to No. 25's engine. Three poor souls were taken down from atop the engine of the second section of 86. Corpses were strewn along the track like rag dolls. Rescuers found it almost impossible to free victims who were pinned under the wreckage. An hour and a half later, six doctors arrived, but they could not do much except try to alleviate the victims' pain with injections. In many instances, rescuers hacked away parts of the tangled hot steel and smoldering splintered wood in order to get to the victims.

It took six hours to recover the injured and dead. Firemen and citizens used axes and shovels to pry the victims loose from the twisted steel and smashed-up wood. One of the cars from the second section of 86 came down on top of a man and woman, pinning them under the wreckage. The last victim was recovered from the pilot (cowcatcher) of the engine that pulled the second section of 86. It had been thrown some fifty feet and was badly mangled.

Two express cars and a baggage car on the second section of 86 were demolished in the accident. The express cars were carrying cold-storage chickens, fish, sausage and tubs of butter. The foodstuff was hurled up and down tracks for a quarter of a mile. A trunk of millenary for women and children flew out of the baggage car. Hats and other articles of clothing were mixed with the ruins of the sausage and butter.

Sixteen of the injured victims were loaded into the sleeping cars of the first section of No. 86 and taken to Elyria Memorial Hospital. Later, the total at that hospital would climb to forty. Every ambulance in Elyria was pressed into service and was lined up waiting at the depot there. Police had to hold back the crowds as the stretchers were carried off the cars and loaded into the ambulances. Two of those victims died soon after reaching the hospital. The hospital corridors were lined with the injured. Doctors worked tirelessly operating on the victims, many of whom lost arms or legs.

One of the reports claimed that amongst all the death and destruction, Mary Marston, an Indianapolis woman who was riding in the second section of No. 86, gave birth only moments after the collision. She and her baby were taken to the Elyria hospital, where doctors said both would be fine. No one ever bothered to record the birth.

More victims died soon after reaching to St. Joseph's Hospital in Lorain, and at least two of them died there.

Contrary to some reports, the Amherst Hospital was not built as a result of the wreck. Ground had already been broken in November of the previous year for the hospital. Although the building was under construction, it was nowhere near being ready for patients, let alone a tragedy of that size. The Amherst Hospital opened its doors in February 1917.

All four tracks were blocked, forcing the railroad to reroute other east- and westbound trains. The heavy steel of the rails on the high-speed track

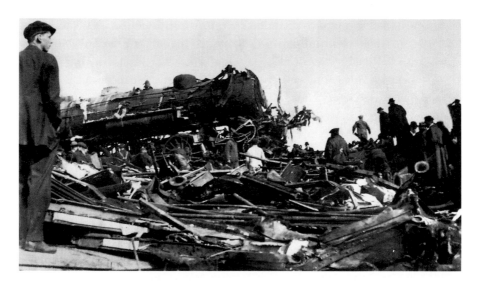

Wreckage of two Pittsburgh-Baltimore-Buffalo Limited trains and a Twentieth Century Limited at Amherst. *Courtesy of the Amherst Historical Society.*

were bowed and contorted. The road was torn up for nearly five hundred yards. Wreckers were brought in to help clear the side tracks. It took two hours for crews to free up the northern track so that westbound traffic could resume. The other three tracks were cleared by the next evening. A crane was used to hoist the rest of the wreckage into a vacant lot on the south side of the tracks, where it was later burned.

Relatives and friends started to pour into Amherst to claim their loved ones, but some of the bodies were so badly mangled that it was almost impossible to identify them.

By the following day, only fourteen bodies had been identified. Furniture stores and carpentry shops were often used as funeral parlors during that period. Twenty-two bodies were lying in the Amherst Furniture store and funeral parlor owned by O.H. Baker. The gruesome task of identifying the victims fell to Coroner Charles Garver. One report claimed there were four stretchers with nothing but bloody body parts. Garver did the best he could to match arms, legs, even heads to bodies. He succeeded in finding some kind of identifying mark for many of the bodies but not all. Clothing taken from the bodies was given a number to correspond to the victim. In some cases, the victims were so mutilated that they were sewn into sacks made of sheets. For some, even their nearest relatives could not identify them.

A young boy from Jerry City, Ohio, named Harold Grant identified his father, Dr. J.C. Grant, by a ring taken from the hand of one of the dead. The victim's body was so badly battered that it was unrecognizable.

Another corpse was identified by a receipt in a coat pocket. A bowling ball and monogrammed shirt helped to put a name to another victim.

One story that floated around and was recounted in area newspapers was of an actress from Detroit who was on her way to Toronto to play a major role in *Peg O' My Heart*. She never showed up to take the stage, and it was speculated that she might have been on one of the three ill-fated trains. It was possible that she may have been one of the four people who were never identified.

Curiosity seekers began to flood into Amherst, coming from all the surrounding communities, blocking the roads with autos and horses and buggies. Amherst quarries and manufacturers were forced to close because their employees left work to go view the disaster.

Looters began filching the injured victims' pockets and stealing valuables from the dead. Survivors claimed to have lost anywhere from $2,500 to $3,000 in cash and valuables. Police arrested one man for taking a scalp from one of the corpses. Apparently, he took it home and put it in a jar of

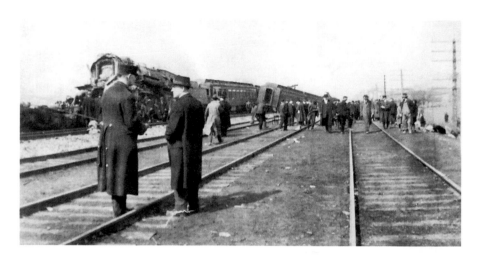

A long view of the train wreck in Amherst. *Courtesy of the Amherst Historical Society.*

alcohol. Several local people were also arrested for pilfering from the dead and injured.

The following Monday, April 3, Coroner Garver began the investigation into the accident. He summoned the crew of each of the three trains, the railroad officials and the first citizens that responded to the wreck. "I intend to go to the bottom of this most horrible disaster," he said, according to the *Amherst Weekly*. "I will subpoena every person known to have any first-hand [*sic*] knowledge as to the cause of this wreck."

After all the evidence was in, it was determined that the accident was caused by forty-nine-year-old Engineer Hess's failure to see the yellow and red signals. It was also noted that although he had been a capable engineman since 1892, he had five different suspensions, including running signals and striking the rear end of a train at the Toledo station.

When the final count of the tragedy was taken, twenty-seven people lost their lives, and forty-seven were seriously injured. At the time, five bodies could not be identified, and no one came to claim them. The New York Central Railroad paid for the five monuments, which were two feet long and fourteen inches high, to be placed at their common grave at Crown Hill Cemetery. In September 1916, the Hungarian Consul of Cleveland identified one of the five bodies by a tattoo. He was forty-six-year-old Ludwig Haladi, and he was traveling east. His gravestone bears his name. The other four victims rest beside him beneath tombstones that read "Died at Amherst Ohio, March 29, 1916."

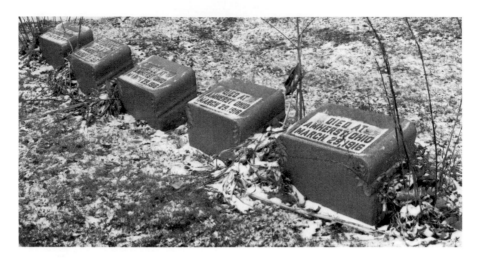

Five tombstones marking the graves of five unidentified victims of the Amherst train wreck. *Photo by Jane Ann Turzillo.*

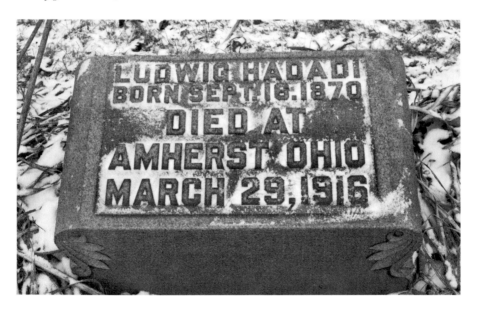

Gravestone for Ludwig Haladi. Months after the accident, the Hungarian Consul of Cleveland identified his body by a tattoo. *Photo by Jane Ann Turzillo.*

In October 1916, Mrs. Richard Thomas of Louisville came forward with the story of her husband's disappearance. She and her children sat night after night in their little home in Kentucky awaiting his return from a trip through the northern part of Ohio.

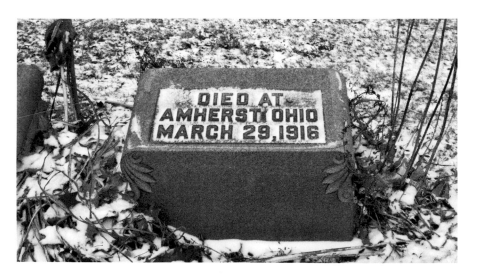

A close-up of one of the tombstones of an unidentified victim of the Amherst train wreck. *Photo by Jane Ann Turzillo.*

At the time of the accident, one of the bodies was believed to be Thomas, having been identified from an envelope in the pocket of a coat thrown over the corpse. But later the body was thought to belong to a Cleveland man, so it was taken there for burial.

Mrs. Thomas read of the wreck in her local newspapers, but her husband's name was not mentioned among the dead or injured. Finally, friends notified her about the mistaken identity. She went to Amherst and enlisted the help of Health Officer Dr. Foster, Elyria Judge Stroup and two friends. There was enough information to have the body exhumed. Thomas was one of the few whose facial features were intact, and so his widow could finally solve his disappearance and claim his remains.

Chapter 3
TERRIBLE RAILROAD ACCIDENT

Sabbath
25
We had 2 funerals in our meeting house William Thompson & Adaph [?]
Thompson son about 10 years old we had a house full Mr. Darling preached

So read the December 25, 1864 entry in Hudson merchant John Buss's diary. Buss, an Englishman who came to Hudson about 1833, chronicled day-to-day life in his diary from when he landed in the village until his death in December 1880. William Thompson and his son died from injuries they sustained in a train wreck about a mile north of Hudson.

Buss's entry on Friday, December 23, 1864, read:

> *Terrible Rail Road [sic] Accident*
> *1864*
> *Dec 23 Rail road smash up This morning 3 cars passengers were broken to pieces 2 cars were burnt 6 passengers killed and about 30 to 50 Badly wounded This happened about one mile north of Hudson near Mr. Bishop's an awefull [sic] sight The middle car was thrown into the creek and smashed all to pieces and then burnt The wounded were scattered all over town some in one family some in another Those that were killed were cut to pieces and Bones Broken very much while some cannot live*

The Cleveland and Pittsburgh Express mail train left Cleveland at eight o'clock that morning with a full load of holiday travelers. Twenty-five

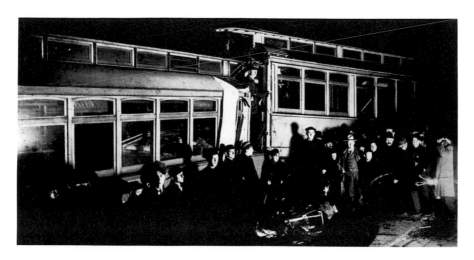

A night scene of passengers waiting at the Hudson passenger depot. *Courtesy of the Hudson Library and Historical Society.*

minutes later, as it approached a trestlework bridge not far from Gaylord Bishop's land in Hudson, the locomotive struck a rail that had either been broken or displaced by freezing temperatures.

The engine passed safely over the bridge, and so did the baggage car. The next car was the first of three coaches. It was filled to capacity with Union soldiers from Michigan on their way to the front. That car crossed to the south side of the bridge safely, even though its trucks (wheel assembly) were probably the first to come off the track. A *Cleveland Leader* article reported that the soldiers left Cleveland with their bayonets fixed. If this had been true, their car would have been full of corpses.

The second coach flew across the chasm and crashed into the bridge abutment on the opposite side with such force that it was smashed into tiny pieces. It fell twenty-five feet down into the ravine to the west side of the bridge and immediately caught fire from the stoves. Many of the passengers, mostly men, were severely injured, and all who were killed were riding in this car. William Thompson and his son were passengers in this coach. They both died the next morning.

The conductor, O.F. Jenkins, narrowly escaped death or serious injury when he stepped from the second car into the first right before the accident. He did receive superficial cuts and scratches.

The second coach dragged the third car, which was carrying, among others, six young women from the Cleveland Female Seminary, down into the ravine after it. The women were on their way to their homes for the

Christmas holidays. The third car wound up on its side, and although it was badly wrecked, only a few of its occupants were injured, and no one was killed. It landed on the east side of the bridge.

One of the women, Jenny Moody, was a teacher who injured her spine. Grace Perkins of Akron received a cut on her lip and fell ill due to exposure to the cold. A young woman from Cleveland escaped injury but lost her purse, which contained a goodly some of money. Julia McClure of Cuyahoga Falls bruised her right hand, but she helped with the wounded.

The stoves in the first coach were tipped over when it was dragged backward, and the car quickly became engulfed in flames. The soldiers were all able to escape, most with no more than a few scratches. Only two had serious injuries. Captain W.W. King, Twenty-fifth Ohio, from Winchester, Columbiana County, suffered a broken leg and "other injuries, dangerous," the *Cleveland Plain Dealer* reported. George Logel, Twenty-seventh Michigan Cavalry, received a broken leg, as well as back and possible internal injuries. Captain Charles McClure, U.S.A., suffered a scalp wound. Major A. Mc. D. Lyons, U.S.A., was cut on the forehead. Sergeant Bockroith, Fifth Michigan Cavalry, had some cuts. Sergeant Rock, Eleventh Michigan Cavalry, sustained injuries to his back and one leg. John S. Gates, Seventh Michigan Cavalry, suffered a leg sprain. Andrew J. Hark, Eleventh Michigan Cavalry, had a slight injury. The rest of the troops lost no time in setting to work with other unhurt passengers in helping to pull the injured and dead out from under piles of wood, glass and burning coal.

The weeping and moaning from the victims was heart wrenching. One of the saddest victims rescued from the flames was a distraught little girl, Mary Robinson, who became an orphan that cold December morning. Both her mother and father were killed right before her eyes. The bodies of John H. Robinson and his wife were badly mutilated. Mrs. Robinson's head was crushed. The family of three was on their way from their home in Petersburgh, Michigan, to visit cousins in Pennsylvania for the holidays.

Oliver H. Perry of Cleveland was one of the first bodies to be brought out from the ruins of the second car. He had a bloody head wound, and his nose was split open. Having been on a hunting excursion, he had a gun and a valuable dog with him. Friends said he loved hunting and would go in the worst weather and stay in the woods for several days in a shelter made of nothing more than branches. Perry had a pocketbook with him that contained several hundred dollars in greenbacks and thirteen dollars in silver. He also had a recipe for some type of dog medicine. No mention was made as to what happened to the dog.

D.H. Miller, from Minerva in Stark County, was killed that morning as well. He suffered lacerations to his arms and body and was partially scalped. He was a medical student in Cleveland.

Also dead was Stephen Robinson of Hudson. His body was grotesquely mangled. He was buried in Glenwood Cemetery.

The newspapers listed the names of forty-eight people who were injured. The victims came from all over Ohio, including six from Hudson who were so close to home when the accident occurred. Several passengers were from Pennsylvania and Michigan. The injuries ranged from superficial bruises and cuts to severe burns and life-threatening traumas.

While the soldiers and uninjured passengers worked to rescue the wounded, the engineer ran down to the Hudson depot and flagged the Akron train that was sitting at the station. A number of people at the depot boarded the Akron train and came back to the wreck to help.

Some of the injured had already been taken to homes in the vicinity, but the greater number were loaded on board the Akron train and taken back to Hudson to be cared for by doctors from Akron and Ravenna. The dead were washed and laid out side by side in the American House hotel to await their families.

Soon, the village was besieged by concerned friends and people wanting to know the details. The telegraph lines were bombarded by anxious relatives. Despite the cold, the citizens of Hudson and the surrounding area came out to see the wreck site for themselves.

On Christmas Eve, John Buss wrote in his diary:

24 Saturday The wounded are suffering very much Yesterday 6 Doctors from Akron and 4 from Ravenna They all had all they could do for the half day Mr. William Thompson died last night from wounds

Thompson most likely died in the early hours of December 24.

The railroad sent out wrecking trains and trains loaded with all the materials needed to rebuild the bridge. A new bridge was in place within a short period of time. No blame was fixed for the accident, as the bridge was fairly new and the road was in good shape.

Chapter 4

TRAINMEN PLUNGE TO A WATERY GRAVE

Three trainmen's lives were cut short on August 11, 1895, when a railroad bridge over Paint Creek in Ross County gave way under an Ohio Southern train just a mile west of Bainbridge. It turned out to be one of the worst accidents in the railroad company's history.

The freight train left Jackson, Ohio, early that Sunday morning, drawing thirty-five cars. It was headed for Springfield with George Henry as the conductor and Clinton "Clint" Radcliffe as the engineer. The front brakeman was Thomas C. Byer. The fireman, William "Will" Houser, had switched from another train to this one at some point along the line.

It was approaching 2:30 in the afternoon when the train approached the two-span, wood-and-iron bridge from the east. There was a water tank approximately two hundred feet east of Bridge No. 36. Radcliffe most likely dropped the cars and ran Engine 34, one of the newest on the road, up for water. It was common to break away from the train and run the engine to the tower, because it was easier to stop the locomotive under the spout with no cars attached. He then returned to the cars and started the train up.

It was thought at first that the bridge had caught fire and was burned significantly at one spot and that the trainmen saw the smoke and thought nothing of it. But actually, within 150 feet of the bridge, one side of a truck—being a complete wheel set under a railroad car—on one of the cars apparently fell off the track. No harm came to the train or the ties under the rails until the locomotive reached the bridge. At that point, the wheels pushed the ties ahead, forming a gap large enough for the truck to slip

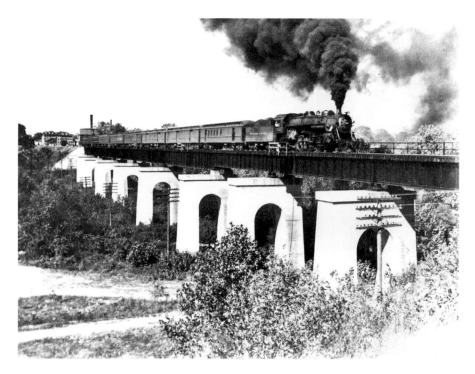

A train crosses the Paint Creek on a bridge at Greenfield. *Courtesy of the Ross County Historical Society.*

through. At 2:35 p.m., the cars started to drop, one by one, and the bridge gave way under the strain. The engine was almost across the 150-foot span of the bridge but was pulled down by the rest of the cars. Radcliffe, Houser and Byer, who were riding in the cab, had no warning, and the engine fell 25 feet backward into the water. The engine went down with Radcliffe's hand on the whistle. It had rained that afternoon, so the water depth was at about 16 feet, although there were differing reports of anything from 10 to 30 feet. The point of the cowcatcher was left sticking out of the water. Eleven cars filled with four hundred tons of coal, two boxcars reportedly carrying two racehorses, one car loaded with firebrick and one empty car were lost to the creek. It was believed that Radcliffe and Houser drowned and Byer was crushed and died instantly. The remainder of the cars stayed up top, and Conductor Henry, along with Hugh Rowland, who was the other brakeman, and the rest of the crew, escaped without harm.

A farmer named Sam Brown and his wife, who lived near the bridge, saw the train go down and heard the whistle screaming until the engine hit the water.

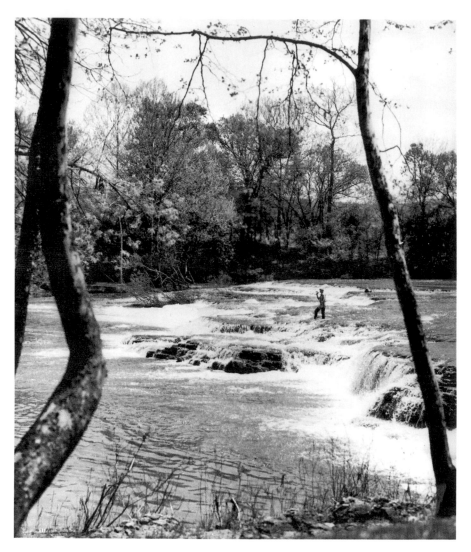

The Falls of Paint Creek. *Courtesy of the Ross County Historical Society.*

At first, the authorities thought four tramps, who were stealing a ride, went down with the engine and coal cars into the creek. Fear spread through Greenfield that three boys, who had come up missing, were also buried in the wreck. The youngsters often rode from town on the train to the water tank at Paint Creek. Luckily, this time they chose to ride on the caboose. A farmer who had been seen at the Bainbridge depot just before the train pulled out came up missing and was never found. Speculation

had it that he boarded the train for a ride home and met his end in Paint Creek. Once the debris was cleared away, rescuers were able to verify that the three trainmen were the only casualties. One of the railroad's employees was riding on the hind trucks of a coal car. The front part of the car went into the river, but the hind trucks stayed on the track, saving the employee's life.

The horses were valued at $50,000 and owned by Scott Goodfellow. One of the horses, named Jim Dean, had its hip dislocated and was injured so badly that it would never be able to race again. Another horse, Billy Russell, escaped with only a few scratches. Of the two, the latter was the most promising racehorse. One report stated that the owner, who was riding in a boxcar with one of the horses, managed to hang on to a stringer in the water. Despite his hips being crushed, he hung on until he was rescued. One of the journalists pulled him out. The man riding with the other horse did not fare as well. He was pinned under the wreckage, and his injuries proved fatal.

It did not take long for a crowd to gather at the site of the wreck. Some of the people tried to help. Another engineer of the Ohio Southern, Oscar Jackson, dove down to the victims. He thought he felt Radcliffe's face and head and then found an arm and tried to pull the body out. However, it was pinned in too tightly in the wreckage, and he could not dislodge it. He tried diving down with a rope and tying it around Radcliffe in order to pull him out, but the body was wedged too tightly.

Within the next few days, upward of five thousand people visited Bainbridge to see the wreck. The citizens were close to running out of food and got to a point where they refused to sell provisions so they would have enough for themselves and their families.

One observer described the scene as if it had been hit by a storm that blew the bridge away, leaving only a few pieces of iron and wood sticking out of calm waters. The engine pilot and a cylinder were visible near the western back of the creek, and a half of a car lying partially submerged was visible on the eastern bank.

Ohio Southern sent for a construction train from Springfield, but it did not arrive and begin work until Sunday evening. Fifty workers began dismantling what was left of the old bridge. New timbers arrived the next day so the crew could begin to rebuild the bridge. Until the bridge was passable again, trains were rerouted over the Baltimore & Ohio bridge.

Divers from Cincinnati arrived too late Monday evening to begin their search for the lost trainmen. Early Tuesday morning, they started the recovery of the bodies.

The Rapids of Paint Creek in 1910. *Courtesy of the Ross County Historical Society.*

Around ten that morning, the body of thirty-year-old Clinton Radcliffe was brought to the surface. He had drowned. He had been an engineer for eight years and worked on the road for a total of thirteen years. His mother and three brothers lived in Jackson. He was not married.

The next body to be brought up at 8:20 a.m. Wednesday morning was that of fireman William Houser. He had worked for the railroad for four years. The twenty-two-year-old had drowned. He was single and also from Jackson.

Wednesday afternoon at 4:20 p.m., Thomas C. Byer's body was recovered. He had been a brakeman for Ohio Southern less than a year. Prior to that, he was a freight conductor on the Baltimore & Ohio Southwestern (B&OSW) for several years. He also worked on the Wabash railroad for about four years. His father was a section foreman on the B&OSW. He lived on East Street in Springfield with his wife, Anna, and two children. He was a month shy of his thirty-seventh birthday. It was said that his face and chest were "horribly scalded."

Houser's and Byer's bodies were found in a standing position, pinned from the waist down between the engine and the tender. Their faces were not disfigured. It looked to rescuers as though they were getting ready to jump but got caught instead.

Radcliffe's and Houser's bodies were taken to Jackson on the O.S. Mail train. Their relatives and friends awaited their caskets at the depot. The coffins were then taken to the families' homes by the other trainmen.

Their funerals were held on Thursday morning, August 15. They were brought to the M.E. Church in Jackson in charge of the orders to which they belonged. Radcliffe's pallbearers were three engineers from Springfield and three Odd Fellows from Jackson. Six trainmen from the Brotherhood of Locomotive Firemen served as Houser's pallbearers. Their caskets remained closed.

The church was packed with Odd Fellows, railroaders and Brotherhood of Locomotive Firemen, as well as relatives and friends. Two sermons were preached, one in English for Radcliffe and one in German for Houser. John Conarty, the fireman who traded places with Houser on that fateful day, was at the graveside services.

The International Order of Odd Fellows and Brotherhood of Locomotive Firemen officiated at the graves, which were close together. One of the floral arrangements at Houser's grave was a locomotive baring the number thirty-four standing on a trestle.

Byer's funeral was held in Chillicothe at his brother-in-law's home. He was buried in Greenlawn Cemetery. Rumors floated around that his wife was so overcome with grief that she lost her mind, but a reporter from the *Chillicothe Daily Gazette* found this was untrue.

Only a few hours before the accident that took the three men's lives, an excursion train carrying some four hundred passengers safely crossed the bridge on its way to a fish fry in Greenfield. A local who crossed the bridge thousands of times said he thought the bridge was in good condition. It was thought that the derailed cars caused the bridge to collapse. But in October 1895, the *Plain Dealer* reported that Attorney Powell had filed a petition on behalf of Radcliffe, Houser and Byer against George W. Saul, who was the receiver of the Ohio Southern Railroad at the time of the disaster. The petition claimed negligence as the cause of the accident. It listed loose, rotten and decaying ties on the bridge; a loose guardrail; and other unsound timbers and supports that needed repair.

The petition further stated that the railroad company knew the bridge was in poor condition and that it was unsafe. The attorney asked for $10,000 for each of the men who died that day in the bridge collapse. Powell had tried for a settlement with the railroad, but there was no agreement on terms, and so the suit was filed.

Saul had been removed from receivership days before the suit was filed. Senator Calvin Brice assumed control for the railroad. The outcome was not found at the writing of this book.

OHIO TRAIN DISASTERS

One evening after the catastrophe, one of the oldest engineers on the B&OSW commented to friends and was reported in the *Chillicothe Daily Gazette*:

> *When an accident happens close to here on any of the roads in the country, in which one man or more is badly injured, I'm on pins and needles until the other two have turned up, and breathe more freely, after I hear of the third one, for I don't know but what I'll be the second or third man to get it.*
>
> *...I'm not superstitious. That's not superstition. I've been on this road a good many years, and I've seen this thing happen too often, and know by this time, that it's not a superstition, but plain facts.*

Chapter 5

NO. 5 IS IN THE CREEK!

Northeast Ohio was in the clutches of a driving blizzard at the end of December 1876. Over a forty-eight-hour period, the heavens had dumped at least two feet of snow on the land, and there were no signs of it letting up. Winds off Lake Erie howled at forty and fifty miles an hour on that fateful Friday night four days after Christmas. The storm blew heavy drifts of snow over the Lake Shore & Michigan Southern Railroad tracks, making passage close to impossible.

When Train No. 5, the Pacific Express, left Buffalo at three o'clock in the afternoon, it needed the help of four pusher locomotives. It plowed twelve to fifteen miles per hour through deep snow and against biting winds toward Ashtabula. Headed west toward Cleveland, the locomotive called Socrates was pulling eleven railcars, including two express cars, two baggage cars, a smoking car, two passenger cars, three sleeping cars and a caboose. The number of passengers was only an estimate that started out at 159 but rose as high as 250 by some accounts.

Most of the passengers were traveling for the holidays. While the storm raged outside, they enjoyed a first-class dinner and perhaps had a smoke. Some of the gentlemen imbibed in a drink and entertained themselves with a game of faro or whist while the ladies gathered for conversation. In the sleeping cars, men relaxed by loosening their cravats and shedding their waistcoats. Women readied themselves for bed by untying their bustles and unhooking the busks on their corsets.

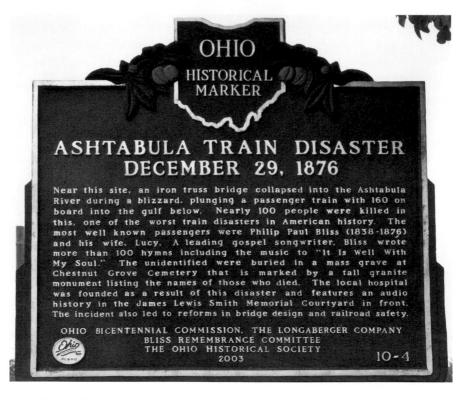

Ohio Historical Marker for the Ashtabula Train Disaster. *Photo by Jane Ann Turzillo.*

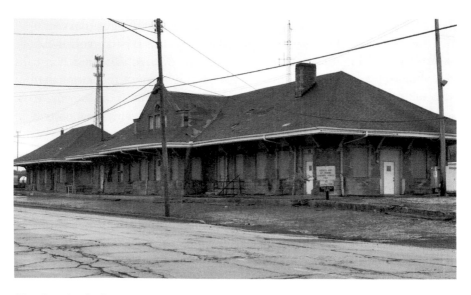

Abandoned train depot near the site of the 1876 wreck. *Photo by Jane Ann Turzillo.*

No. 5 was already an hour late when it left Buffalo. The going was rough against the blinding snow and rampaging winds. Needing more power, the train took on a second engine named the Columbia at Dunkirk, New York. Daniel McGuire was at the throttle of the Socrates, and G.D. Folsom of Cleveland was the engineer on the Columbia. The conductor was B. Henn.

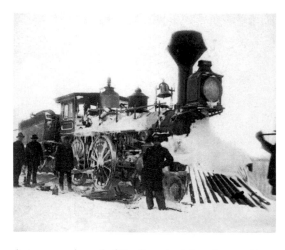

A stereograph card of the Socrates taken the morning after the Ashtabula train accident. *Courtesy of the Jennie Munger Gregory Museum and Research Room.*

When No. 5 got to Erie, it was two and a half hours late. By 7:28 p.m. the Pacific Express was three hours behind as it approached the 150-foot-long Ashtabula Creek Bridge. The bridge was a double-track iron structure, consisting of two Howe trusses. The Ashtabula station was only about 1,000 feet from the other side of the ravine.

The storm was at its worst. The locomotives were struggling to pull their load at ten miles per hour. The headlamp was of little use against a whiteout. The train crawled across the bridge until Socrates reached the other side.

McGuire heard a sickening crack. It was a lug breaking on the second angle block on the south truss of the west abutment. Three of the I-beams that formed the upper chord—the bridge's compression member—on the south side started to buckle. McGuire's heart sank when he felt like his engine was struggling to pull uphill. It was the bridge sinking. He gave the Socrates steam and safely drove it onto the west abutment.

The south truss began to fall, and the bridge deck sloped to that side. The tender and engine Columbia derailed. The tender made it to the west abutment, but the coupling that held the trailing engine broke. The Columbia slid down the west side of the ravine and landed upside down on top of one of the express cars.

McGuire brought his engine to a stop and laid on the whistle to call for help. He looked back and watched, horror-stricken, as the bridge collapsed and the eleven cars plunged eighty-two feet into the frigid Ashtabula River. The earth shook when the cars landed. The crash echoed down the valley

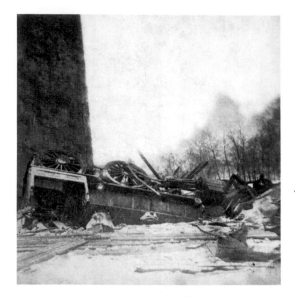

Left: Stereograph card of Columbia. The second engine pulling the doomed train fell near the west abutment. *Courtesy of the Jennie Munger Gregory Museum and Research Room.*

Below: The Ashtabula wreckage site of the ill-fated No. 5 Pacific Express. *Courtesy of the Jennie Munger Gregory Museum and Research Room.*

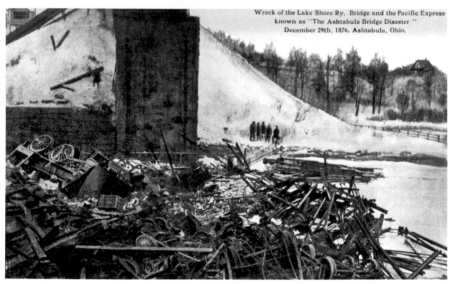

Wreck of the Lake Shore Ry. Bridge and the Pacific Express known as "The Ashtabula Bridge Disaster" December 29th, 1876, Ashtabula, Ohio.

and rolled out of the ravine so loudly that it could be heard half a mile away. Then silence. Dead silence.

Two baggage cars and the second express car had landed in a line across the ravine. One of the passenger coaches landed upright in the river but was crushed when the smoking car came down. A second passenger coach landed on its side on top of some of the bridge wreckage. One of the cars flew eighty feet to the south. A sleeper landed beside it. A third car came

down on top of those two, smashing one of them. The tenth car landed against the others with its forward end down and its back end in the air. The last car landed in the river.

Stunned and immobile at first, it took a few moments before the survivors realized they had to get out. The scene of the dead and mutilated inside the cars must have been horrific. Seconds slipped by before painful and frightened shrieks rose out of the creek bed, breaking the deadly silence. Travelers who were not too badly hurt squeezed through the

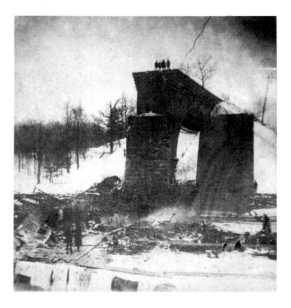

Stereograph card of the wreck from the west abutment looking east. *Courtesy of the Jennie Munger Gregory Museum and Research Room.*

windows into the blizzard and three-foot-deep icy water. In the effort to save themselves, they left behind passengers who were impaired or trapped.

Small fires shot to life from overturned lamps and the heating stoves. High winds caused flames to spread rapidly until the entire wreck was an inferno. Agonizing screams intensified as trapped souls faced cremation.

J.E. Burchell of Chicago told a *Cleveland Leader* reporter that once the train was on the bridge, he heard cracking sounds coming from the front and rear of the car. The sounds got louder, and then he had a terrible weightless, sinking feeling. When the car hit bottom, he was thrown from his seat. He looked up and saw broken twisted shapes that looked nothing like the car he had been riding in.

"Fire!" A woman close to Burchell panicked and cried for him to help her. The doors were blocked by the stoves, so one of passengers broke out a window. Burchell grabbed the screaming woman and shoved her out the opening. He later found out her name was Minerva Bingham, and she was also from Chicago.

Burchell and Mrs. Bingham got out of the car and looked around at the devastation. The train was lying facing in all directions, with most cars in the water. "Some on end, some on the side, crushed and broken, a terrible but

picturesque sight." The car he and Mrs. Bingham had been riding in was on its side, both ends caved in, and flames were devouring it.

The snow and whirling winds were bone-chilling, so Burchell went back for his coat. At first, Mrs. Bingham tried to maneuver through the snow, but it was no use. Her leg was broken, and her back was injured. Burchell picked her up and, with great difficulty, made it through waist-deep snow up the embankment. He got her up as far as the engine house near the edge of the ravine. Forty-five minutes later, the injured began to arrive at the engine house, fifty-two in all, he recalled.

From where Burchell stood on the bank, he could see the pandemonium below. Most of the cars were built of wood, so the fire spread fast. The entire train was ablaze within a short period of time. Huge fireballs burst out of the ravine. The blaze was so intense at least a half hour passed before rescuers could get close enough to the wreck to carry out the victims.

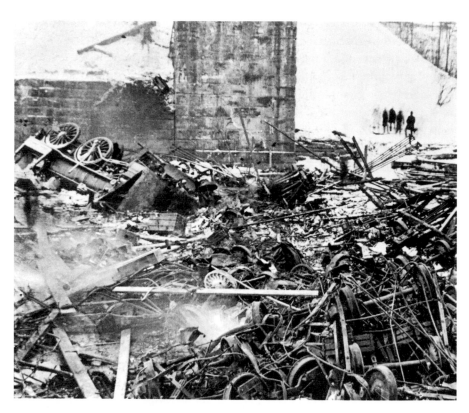

Another view of the wreckage of the Pacific Express train at Ashtabula. *Courtesy of the Jennie Munger Gregory Museum and Research Room.*

One of the first people out to the wreck was a stock drover, who told newspapers that the train and its fragments stretched all the way across the ravine, touching the abutments on both sides. He said the fire took no more than five minutes to engulf the wreckage.

Firemen from the Ashtabula Fire Department arrived with fire engines Protection and Neptune. Another engine, Lake Erie, which was closer, was never deployed. Fire Chief G.W. Knapp asked the station agent Henry Apthorp twice if his firemen should start trying to put out the fire. The agent told the fire chief to get the injured out of the wreck. Apthorp replied, "Never mind the water. We want to get out the wounded." Apthorp's orders had come from Cleveland. His superiors claimed they were afraid that spraying water into the cars would drown any survivors.

When the firemen did not act, a disorganized brigade of citizens grabbed buckets in a futile attempt to put out the fire. Even though there was no headway in knocking down the flames, men tried to rescue trapped passengers. The victims who were pulled out looked like discarded rag dolls lying in the snow.

By 10:00 p.m., all able-bodied citizens made their way down to the scene in spite of there being no road or path down to the wreck. The storm continued dumping snow throughout the night. In addition to the fire, the freezing temperatures impeded the rescue attempts.

J.E. Burchell told a reporter that he saw the Columbia lying in the water, "smashed to pieces, the ruins breathing steam and fire." Folsom, the engineer of the Columbia, escaped the fire with a cut on the head and a broken leg. The engine's fireman, Peter Levenbroe, was badly injured and later died from those injuries. The conductor of the train emerged unscathed.

Charles S. Carter, a passenger from Brooklyn, New York, had been in the "palace" car having a friendly game of cards with three other gentlemen. The three were startled when window glass broke in the front part of their car. The next thing they knew, the car was falling.

Carter held on for dear life. When the car hit bottom, he realized that he, himself, was mostly unscathed. His companions were not so lucky. One of them was dead. The other, Henry W. Shepherd, also from Brooklyn, feared that he had a broken leg.

Almost immediately, flames from the overturned stove began to charge toward Carter and Shepherd. Carter reacted fast to get Shepherd out one of the windows. The broken leg was an impediment to the escape, but they made it out. Once Shepherd was safe, Carter went back for a woman at the front of the car, who was crying for help. He got her out, but she had few clothes on, so he gave her his overcoat.

At 3:00 a.m., doctors realized Shepherd's leg had been crushed beyond repair, so they needed to amputate it. When Carter got to a hotel room, he found that he was bruised in several places.

A townsman rescued a mother who was struggling to get out of the wreck. As he carried her to solid ice, she wailed that her little daughter, only four years old, was still inside. He ran back to the blazing car to try to get the child. In horror, he saw that she was pinned by splintered wood, and he could do nothing. The child cried out to her mother as the flames reached her. The mother dropped to the ice in inconsolable grief.

Another heroic act was performed by the porter of a sleeper, the Palatine. He succeeded in evacuating everyone from his car. His name was Stewart, and it is not known whether that was his first or last name. The Palatine hit another sleeper when it landed and then turned on its side. Stewart succeeded in raising a window and sliding through to the outside. He then stamped on each window until it broke, so that the twenty passengers could get out safely. One of the passengers was too sick and could not help himself. When Stewart realized this, he immediately called to the others for help in getting the man out. Only two people volunteered to stay and help him, a woman and a man, who was also ill. The three of them succeeded in getting the last passenger through a window. Porter Stewart saved every man and woman in his car.

The best-known persons on the train were Philip and Lucy Bliss of Clearfield County, Pennsylvania. He composed such hymns as "Almost Persuaded," "Hold the Fort," "Hallelujah," "Let the Lower Lights Be Burning," "What a Saviour!" and "Wonderful Words of Life." He was a gospel singer with a bass-baritone voice. Philip was able to get out of one of the windows, but his wife was pinned in the wreckage. Instead of saving himself, he went back to stay with his wife. Some reports said their sons, four-year-old George and one-year old Philip Paul, were with them and also died in the wreck, but that was not the case.

The Bennett family was on their way from New York to Jefferson in Ashtabula County. The mother, who was pregnant, and the father scrambled from the wreckage to safety. Their four children were saved by tossing them from the arms of one man to another over a burning pile of wood. One of the children was seriously injured. Mrs. Bennett gave birth the next morning, hastened, no doubt, by the accident.

The Culver house, American house, Smith's tavern, Jefferson house, Manning's store, A.P. Thorp's house, Fisk house and other homes threw open their doors to the injured and those left destitute by the disaster. When

the beds were filled, the injured were cared for on makeshift beds on the floors of parlors, dining rooms and offices—anywhere there was space.

The railroad sent a train to Ashtabula from Cleveland with two surgeons, Doctors Schneider and Boynton, and three other unnamed physicians, as well as medical supplies and blankets. It left Union Depot at ten o'clock that night with a passenger car and sleeper and perhaps an express car. It was drawn by two engines and took almost four hours to plow through the deep snow on the tracks to arrive at two o'clock in the morning.

Schneider, Boynton and their colleagues joined with physicians from Ashtabula and surrounding areas. They made the rounds of the hotels and homes amidst heartrending cries and moans from their patients and did the best they could to administer care and alleviate suffering. Some of the patients could not be helped. Others lost limbs, suffered internal injuries or endured excruciating burns. The luckier ones bore no more than frostbite, cuts and bruises.

Also aboard the train were the LS&MS general superintendent, Charles Paine; the division superintendent, Charles Couch; train dispatcher Henry Stager; and the chief engineer of the railroad, Charles Collins.

Collins broke down and wept uncontrollably at the site of the accident. He had inspected the bridge only ten days earlier and was of the opinion that it was one of the most substantial in the country. Six locomotives were used to test its strength during that inspection. When he got the news of the accident, he could not believe it had collapsed.

The chief engineer told reporters for the *Cleveland Plain Dealer* and the *Cincinnati Daily Times* that the bridge was a Howe Truss built eleven years earlier entirely of iron in the Cleveland shops. Designed by Amasa Stone with Collins's help, it was 157 feet in length and stood 69 feet above the water. It had an arch of 150 feet in the clear.

Reporters pressed him for an opinion as to why the bridge went down. The only reason he could give was the cold. He thought there was a possibility that some of the braces or under parts snapped because of the temperature. He estimated the loss of the bridge alone to be in the neighborhood of $75,000. He said he expected that a temporary bridge would be in place in ten days. He could not hazard a guess at the financial loss of the train itself.

By 6:00 a.m. the next day, the special train was backed in to the station and the beds were made up for the most critical patients. Victims who were in good enough shape to sit up were accommodated as well. The train left for hospitals in Cleveland a bit after eight that morning.

While doctors labored to save lives and rescuers worked furiously to get to the injured, masked robbers came out of the dark to steal valuables from

the wreck. They looted the dead—even taking clothing off corpses—and accosted the living as they scrambled to get away from the inferno. In some cases, the bandits murdered injured passengers for their money and jewelry. One young man had secreted his heirloom watch, some money and his mother's jewelry in different parts of his clothing. As he limped away from the fiery crash with broken ribs and severe gashes, cutthroats grabbed him and punched him in the stomach. They snatched the money and jewelry but missed the watch.

As daylight crept into the ravine, it revealed the total horror of the night before. The temperature had dipped even lower, and the winds were relentless. The men whose job it was to clean up were faced with the charred wreckage and debris. What was left of Pacific Express No. 5 stretched all the way from the east abutment to the west abutment. At least a dozen fire-shriveled bodies were strewn throughout the ruination. Only one had any semblance of being human. A pair of scissors and a hank of gray hair were found beside one pile of embers.

It was almost impossible to tell what materials were from the bridge and what were from the train. Heaps of twisted iron were embedded in the ice of the creek, making it difficult to extricate the dead from underneath. Most of the wood had burned in the night, but small fires still smoked.

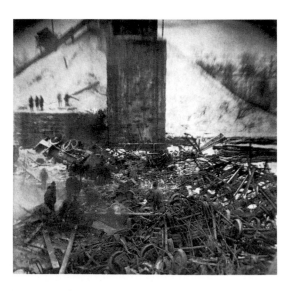

The wreck from the east abutment looking west. Workman were removing the dead. *Courtesy of the Jennie Munger Gregory Museum and Research Room.*

The men went about their ghastly task with urgency, maybe hoping they would find someone alive. By 11:00 a.m., thirty bodies of people who had been burned alive had been removed from the wreckage, most burned beyond recognition. Eighteen more would finally be recovered. The creek was three to four feet deep, and rescuers' worst fears were realized when it was dragged. By 2:00 p.m., several corpses that were frozen in the water had been recovered.

At least one in five passengers had perished in

the disaster. In the final counting, ninety-two people died. A hasty morgue was set up in the Lake Shore & Michigan Southern freight house. Those bodies that stood a chance of being identified were taken up there for possible recognition by relatives and friends who had already begun pouring into Ashtabula. Some of the dead were recognized by their families. Others were beyond recognition.

Coroners worked every angle they could think to identify bodies. A letter addressed to J.B. Pickering of Chicago was used to identify his body. A single leg was recovered with a boot resembling ones worn by Dr. Washburn, rector of the Grace Church in Cleveland. The leg had cloth from two pairs of drawers clinging to it. The pieces of cloth were shown to his wife, who said they were not his.

Mary Birchard, cousin to then-governor Rutherford B. Hayes, was on the ill-fated train. She was on her way to her sister's in Elyria to collect a $20,000 inheritance from an uncle. Her body was not found.

Eleven of the bodies were taken to Cleveland for the undertakers there to prepare for burial. One unidentified man remained in Ashtabula until after the first of the year. The newspaper published a description. He was light complexioned with auburn hair. Dressed in a dark cloth coat, dark cashmere trousers and calfskin shoes, he was a large man and weighed about two hundred pounds. His undershirt and drawers were grey merino wool; his socks were hand-knitted wool. He wore checked leggings that reached just above the knee and were buttoned closely over his drawers. Buttons on his clothing were brass and stamped with the word "Excelsior." A black rubber comb was found in his pocket.

Letters poured into the coroner's office from family members asking about possessions of their dear ones—pieces of jewelry, letters, wallets, watches, anything that had belonged to the people they loved. As the coroner painstakingly identified belongings, he wrote to the victims' families in an effort to get the items into the right hands.

Public sentiment in Ashtabula was strongly against the managers of the railroad. The citizens thought the company was anxious to get the bridge removed as soon as possible so that any human remains would wash away, leaving no evidence for claims from the families of those who had perished.

Another bone of contention was the fact that a train dispatcher in Cleveland telegraphed that no water should be used on the burning cars. The engine house close to the west pier had steam pumps used to force water up the hill into a tank. There was plenty of hose on hand and a powerful rush of water could have been thrown on the wreck. The dispatcher admitted

he had sent the telegram. The public thought many lives could have been saved if the fire was put out. Families and friends of the victims believed the company wanted the fire to burn any evidence.

At 9:00 a.m. on Saturday, December 30, 1876, a coroner's jury assembled to investigate the tragedy. Edward W. Richards was the justice of the peace and the acting coroner. Theodore Hall acted as the jury's counsel. Ashtabula citizens George W. Dickinson, T.D. Faulkner, H.L. Morrison, Henry H. Perry, F.A. Pettibone and Edward G. Pierce were selected as jurors. It took them sixty-eight days to sift through the evidence and come up with a finding.

On January 12, the state legislature of Ohio appointed engineers to investigate the use of iron for the bridge. The American Society of Civil Engineers commissioned a third investigation. All three groups used engineers to examine the evidence.

The concept of the iron bridge was designed by Amasa Stone, director of the LS&MS and president of the Cleveland, Painesville and Ashtabula Railroad. Stone had worked with his brother-in-law, William Howe, to develop the Howe Truss Bridge some years before. It was thought that Stone chose to build the Ashtabula Bridge completely of iron instead of using some wood because he wanted to be innovative. It is also interesting to note that his brother, Andros, was a partner in the Cleveland Rolling Mill, the company that provided the iron beams for the bridge.

Stone had detailed drawings for the bridge prepared by an engineer, Joseph Tomlinson. Known for his dominating personality, Stone fired Tomlinson when the two could not agree on the specifications for how much stress the compression elements would take. Tomlinson wanted a smaller allowable stress than did Stone. Later, the engineer testified that when the iron came from the mill, it was not up to the specifications, but it was used anyway.

Engineers for the state discovered the top cord and the compressive brace failed in the second and third panels of the south truss. They further stated that the design was faulty. Because the bridge was a Howe Truss design made of all iron, it was excessively heavy. Beyond that, there were a number of things in the design and construction they found that were faulty. The compressive diagonal braces were mixed in sizes. I beams were not tied together properly. End bearings were defective. The bridge construction was not in line with established engineering principles, according to all three reports. Instead of being tied together, the members of the trusses just rested on one another. The specific cause of the collapse was a fatigue fracture that started at a small air hole in a cast-iron block. The crack grew with repeated crossings and stress over the eleven years since it had been built.

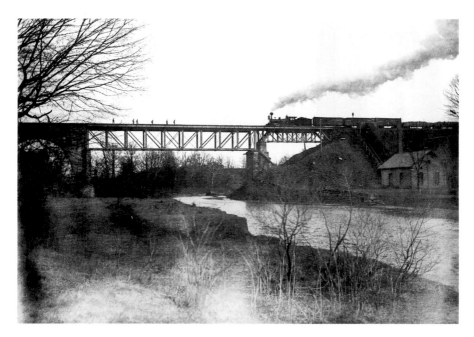

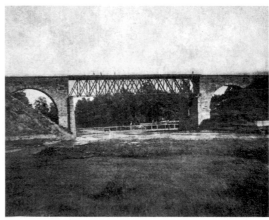

Above: The temporary bridge erected after the Ashtabula Bridge Disaster. *Courtesy of the Jennie Munger Gregory Museum and Research Room.*

Right: Stereograph card of the Ashtabula Bridge the summer before the disaster. *Courtesy of the Jennie Munger Gregory Museum and Research Room.*

It was decided that the railway company bore the responsibility because of the faulty design of the bridge. The company was also responsible for the poor use of heating stoves in the cars. The cars should have been equipped with heating apparatus that would immediately extinguish a fire if turned over.

The report also found fault with the fire department for not attempting to put the fire out with whatever means were at hand. While the fire department hauled two engines over a mile distance on impassable roads, an engine and

Many say the Chestnut Grove Cemetery is haunted. *Photo by Jane Ann Turzillo.*

a steam pump and hose were close at hand at the pumping house. Fire Chief Knapp was held accountable for this. More than one source claimed he drank heavily.

On January 19, 1877, the town of Ashtabula said goodbye to nineteen of the unidentified bodies. Two of them were believed to be Phillip and Lucy Bliss. All businesses were closed out of respect as the poor souls were laid to rest after services held in both the Methodist church and St. Peter's. The procession of sleighs and mourners on foot to the Chestnut Grove Cemetery was more than one mile long. The railroad bought the plots for victims.

In 1895, an obelisk marble monument standing thirty-seven feet high was set in place to memorialize the unidentified victims. Lucretia Garfield and Governor William McKinley were among those who donated to the cause.

The railroad's chief engineer, Charles Collins, tried to resign from the company, but the board refused his request. After testifying before the state legislature committee, he went home to Cleveland and committed suicide. He was found two days later in his bedroom with one gun in his hand and another close by. He had shot himself through the roof of the mouth. His family said he felt great responsibility for the bridge tragedy. He had wept for days after the bridge collapse, and his loved ones had

A memorial at Chestnut Grove Cemetery honors the nineteen unidentified dead of the Ashtabula train disaster. *Photo by Jane Ann Turzillo.*

Charles Collins's mausoleum is near the memorial in the Chestnut Grove Cemetery. *Photo by Jane Ann Turzillo.*

been worried about him. His vault is near the graves of the unidentified in Chestnut Grove Cemetery.

A murder theory floated around, spawned from a police report that suggested the fatal wound had not been self inflicted, and his autopsy

records were missing for several years. In 1878, Collins's skull was sent to Dr. Stephen Smith, a surgeon at St. Vincent Hospital and professor at the University Medical College in New York City. His notes were thirteen pages long. The last sentence reads, "My opinion is that Mister Collins came to his death by a shot wound inflicted by other hands than his own." No arrest record has been found.

Amasa Stone would never take any responsibility for the accident, but fate caught up with him. In later years, he ran into financial difficulties when several of his steel mills failed. He committed suicide in 1883 and is buried at Lake View Cemetery in Cleveland Heights.

According to the Lake Shore & Michigan Southern Railway 1877 Corporate Stockholder Report, the railroad paid out $495,722 in claims.

What would a disaster be without ghost stories? It is said that the spirits of those who were killed in the accident congregate at the site in the ravine every anniversary. Wraiths of those who are buried in the cemetery rise from their graves to walk among the tombstones. They wear winter clothing of the 1870s. Some of them scream late at night.

Charles Collins has been seen leaning against the memorial, weeping. And he apparently wants to be left alone, as a young couple found out a few years ago when they were visiting his mausoleum. No one else was in the cemetery at the time. The young man was going to prove to his girlfriend that ghosts

Inscription above the door to Collins's mausoleum. *Photo by Jane Ann Turzillo.*

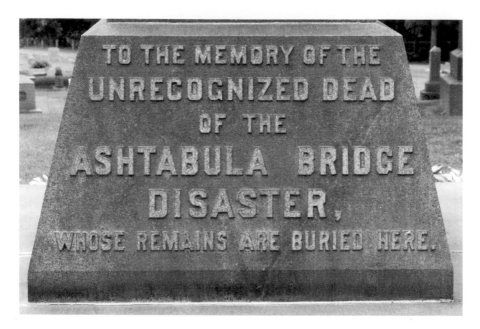

Inscription on one side of the memorial to the unidentified dead. *Photo by Jane Ann Turzillo.*

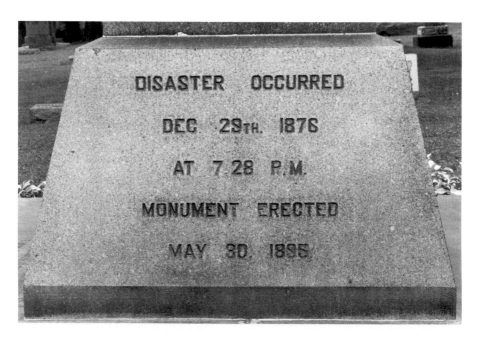

Inscription on one side of the memorial to the unidentified dead. *Photo by Jane Ann Turzillo.*

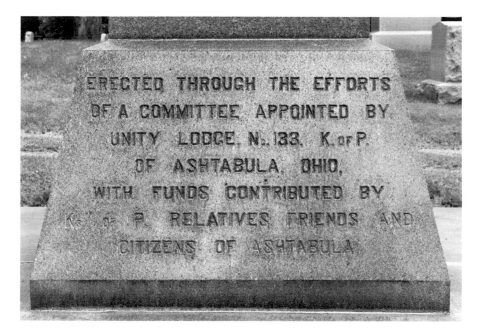

Inscription on one side of the memorial to the unidentified dead. *Photo by Jane Ann Turzillo.*

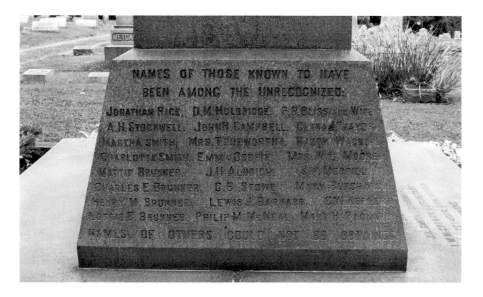

Inscription on one side of the memorial to the unidentified dead. *Photo by Jane Ann Turzillo.*

do not exist. While the young lady was using her phone to take pictures of Collins's monument, her friend turned on the tape recorder of his phone. Later, as she was showing him her photos, he played the tape back. Chills covered their bodies when they heard a male voice say, "Leave. Please leave."

STEREOGRAPH PHOTOS

The stereograph photos in this chapter are two identical images printed side-by-side to produce a single two-dimensional or three-dimensional image when viewed through a stereoscope. They were popular through the nineteenth century.

Chapter 6
TRAGEDY AROUND THE BEND

The eastbound Chicago and Wheeling passenger express No. 14 on the Baltimore & Ohio Railroad was three hours and ten minutes late, so Engineer Hugh G. Lipscomb was running hot when he charged through the western end of the train yards at Bellaire, Pultney Township, and rounded a sharp curve near Klee Crossing. A number of buildings on that curve prevented him from seeing around the bend. Little did Lipscomb know that tragedy awaited on the other side.

The ill-fated passenger express left Chicago for Pittsburgh and Wheeling at nine-thirty the night before. The train was divided in Chicago, with part of it going to Pittsburgh by way of Akron and the other part traveling through Newark to Wheeling.

It was 3:15 p.m. on Saturday, September 28, 1907, and westbound freight train No. 25 was moving slowly into the siding. Its engineer, Lincoln N. Galbraith, was under orders to meet the express at the western end of the yard. As the passenger express came around the curve, it was supposed to have gone safely onto the main line, but through carelessness, the switch had not been turned, so the express barreled onto the west siding of the double track.

Lipscomb had no time to apply the brakes or jump to safety. His Goliath engine crashed head on into the freight's locomotive—one of the biggest on the road— reducing both to a snarled, hissing pile of iron. A portion of one of the engines rolled over the embankment. The two engineers, a conductor and a newsboy met their deaths almost instantly.

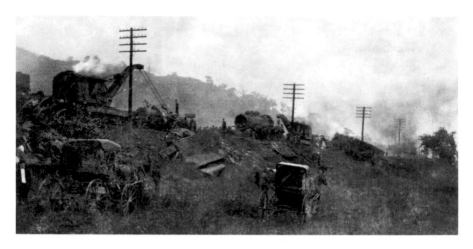

Scene of the accident in Bellaire where ten people met their deaths. *Courtesy of the Bellaire Public Library.*

The smoker on the passenger train sustained horrific damage when the baggage car telescoped all the way into it. Every seat in the smoker came loose from its fastening, leading to severe injuries to every occupant. Passengers in the other day car and the two Pullman coaches were thrown from their seats, but there were no serious injuries.

Engineer Galbraith of Newark endured a horrible end when he was burned to death by steam billowing from the engines. He was forty-eight years old.

The forty-eight-year-old Lipscomb was trapped under his engine with one of his legs entangled in the twisted metal. Steam was scalding his face and body. Rescuers were not able to dislodge his leg, and doctors could not get close enough to administer any anesthetic. Still he begged the members of the yard force to cut his leg off. "Chop my leg off, will you?" he cried. He was still conscious when the doctors amputated the leg above the knee, thinking that was the only way to save his life. News accounts said, "He bore it bravely." He was taken to the hospital but died an hour later, conscious until the end.

At the time of the accident, Fountain Earl Motz, the conductor of the freight train, had been riding on the engine from Benwood to the west end double tracks, as was customary to get his orders. When the two engines collided, steam billowed into the cab and boiled the twenty-eight-year-old man alive.

The saddest death was of the newsboy, Harold Seitz, who was only sixteen years old. He usually sold papers for the Union News Company at the B&O

and Pennsylvania stations, but Saturday, September 28, was his first run on a passenger train. He packed a basket of papers and boarded No. 14 at Newark. He was going to transfer at Bellaire. Instead, he wound up fatally injured in the crash. He was lying on the grass with a doctor kneeling over him, saying, "Little boy, if you have parents or friends, tell me who they are, for you are going to die."

Harold's mother and father, who were from Massillon, were traveling in Mexico, so he was staying in Newark with his uncle. He whispered his parents' names and that of his uncle before he was taken to the hospital. He lived another three hours, but his family did not make it in time to be with him when he died.

At least four others lost their lives, and twenty more were hurt in the wreck. Among the injured was Alfred Dalby, the general musical director of Richard Carle's Spring Chicken company, a musical comedy group. Dalby was enjoying an after-dinner cigar in the smoker of the passenger train when the collision happened. He was pinned by his right arm under a heavy timber. Several newspapers reported that his arm was crushed, necessitating amputation, but the *Newark Advocate* claimed his arm was saved. The manager of the theater company communicated by phone that Dalby would recover, but he would not be able to resume his position of musical leader for some time.

Dalby was well known in musical circles, having orchestrated all of Richard Carle's music. Before the accident, he had been with the Hurdy Gurdy Girl company and had just joined the Spring Chicken company.

The rest of the troupe, which numbered seventy-five, had been riding in the rear car, and no one was hurt. They were to perform in Wheeling that very afternoon and evening, but the performances were canceled.

The ladies in the theater company assisted in caring for the injured. Their dresses and costumes were stained with blood, but they tore up their petticoats and tried to bind up wounds as best they could. They comforted victims and stayed with them until help arrived.

The conductor on the passenger train, James H. Moore, described what it was like inside the train when the accident happened. He had walked through the smoking car looking for a seat. The seats were all taken, so he went into the ladies' coach and found a place to sit. It was only a few moments later that the train stopped abruptly with a violent jolt. The passengers, including Moore, were thrown from their seats. He received bruises to his body and hands, but he tried to quiet some of the women who were panicking and becoming hysterical.

Moore was able to quiet them and get them back in their seats. Then he walked back to the smoking car and found that the baggage car had ripped into it, shoving the seats and their occupants toward the rear corner. The sides of the smoker were spread apart. The passengers were jammed together and pinned under heavy timbers from the baggage car. Conductor Moore had been on the road since 1879, and this was the first accident in which he had ever been involved.

Spectators began to gather at the scene but were afraid to help get any of the injured out. Trainmen worked fast to free the victims as they feared the wreckage would catch fire.

The railroad's General Manager Fitzgerald, who was on an inspection tour in Benwood Junction, and General Superintendent W.C. Loree of Wheeling immediately came to the scene and directed the rescue operation. The Benwood train was converted into a relief train with medical personnel and supplies and rushed to Bellaire. Moore was assigned conductor of that train. Rescue workers found it difficult to remove the passengers from the totaled smoking car. The slightest movement to clear the debris elicited shrieks of agony from the victims who were trapped in the tangle of iron. The injured were taken to Glendale, West Virginia and Bellaire hospitals.

One unsubstantiated story told was of victims being taken down the bank to a houseboat, where two of them died. An uninjured passenger on the houseboat asked if any of the injured were Catholic. Some said they were, so he presented them with a crucifix and prayed with them. One individual who was in very bad shape said he was not a Catholic, but he wanted to hold a crucifix. A cross was placed in his hands, which he clutched to his chest. Five minutes later, he was dead.

By the next night, a message from Loree's office was released saying operator error was to blame for the accident. It was not immediately known who that operator was, but Loree said a thorough investigation was under way. Wrecking crews began to arrive at the scene to begin the clean up. They figured the property damage alone was at $60,000.

Early Sunday morning, a crowd gathered at the B&O station in Newark to await the arrival of train No. 7, which brought the bodies of Engineers Lipscomb and Galbraith home. It crawled into the station at 7:25 a.m. The Criss Brothers & Jones undertakers took the remains to the homes where they were prepared for burial. At 2:40 a.m. the next day, Conductor Motz's remains arrived on train No. 103. The same undertakers took charge of his body.

Lipscomb was born in Baltimore, Maryland, and had worked for the railway company for twenty-five years, starting out as a fireman. After

seven years, he became an engineer and had run the engine for eighteen years. He married Katherine "Kate" Turner after moving to Newark. They had been married twenty-two years and had three children. Their daughter, May, was nineteen years old. Their two sons, Harry and Ralph, were twenty-three and fourteen. Services were held at Lipscomb's home. The Brotherhood of Engineers and Eagles attended in numbers. Six of them were chosen to be pallbearers. Katherine buried her husband in the Cedar Hill Cemetery in Newark.

Ironically, the day before he was killed, he was talking with a good friend. During the conversation, he said, "We never know how soon the end may come."

Lincoln Galbraith, described by his many friends as a jovial fellow, was originally from Barnesville. He went to Newark and took a job with the B&O as a fireman seven years before the fatal accident. In short order, he was promoted to engineer and had been running on the Ohio division for five years. His funeral service was held on the Tuesday following his death at his home under the auspice of the Brotherhood of Locomotive Engineers. He was also buried at Cedar Hill Cemetery.

Born in Cincinnati, Arkansas, Conductor Fountain Motz had worked for the B&O for nine years, first as a brakeman and then as conductor. He was the youngest conductor on the Ohio division of the B&O Railroad. He was married to Amanda Gordon for seven years and had two small children: Alice, six, and Wilbur, four. His widow remembered him as a "loving husband and kind and affectionate father." His remains were taken to Irville in Licking County for burial.

On Wednesday, October 10, the Ohio Railroad Commission met in Wheeling to start its probe. The B&O wreck was the first big accident the commission had been called to investigate. The superintendent, the dispatcher and the crew members from both trains had been subpoenaed to testify.

What the commission discovered was carelessness on the part of tower operator Ross Buchanon, who was stationed at Schick's on the Wheeling division of the B&O. At first, the commission believed Buchanon had worked for twenty-seven hours straight, but after the officials dove into the evidence, they determined that was not true. The prosecuting attorney of St. Clairsville issued a warrant for the operator's arrest.

Buchanon claimed to have seen "a number of foreigners working at the switch to the track the freight was on." This was never substantiated.

Chapter 7

TRAIN WRECK AT HOODOO CROSSING

Railroaders called the baseline crossing at the boundary between Wyandot and Seneca Counties "Hoodoo" Crossing for good reason. Just three miles north of Carey, the crossing was the site of two separate freight trains that had ditched in the early 1900s. A third, more serious accident, happened to a Big Four passenger train No. 1 at that same spot on a cold Sunday, January 14, 1912, shortly after noon. Thirty-four people were injured, some seriously.

The train originated in Detroit, Michigan, with Conductor William Caskey from Detroit in charge. It was composed of a parlor car, a dining car and a combination baggage car and day coach. Bound for Cincinnati, No. 1 was a flyer, known for speed, but was late by anywhere from thirty minutes to several hours, depending on which newspaper you read.

Engineer Harvey Thomas of Springfield had the throttle wide open in an effort to make up the time. He said the train was rolling south about a mile a minute on the downgrade stretch from Berwick.

The dining car left the track first about two or three hundred feet before the crossing and bumped along on the ties for a hundred yards or so. It turned on its side and hauled the day coach over with it. The two cars were dragged along behind the rest of the train for another 150 feet and into the crossing. The elevation of the road at that point caused the two cars to detach from the baggage car and tumble over a steep embankment, snapping off telegraph poles as they rolled. They landed in a ravine on their sides, parallel to the track.

The Big Four Depot at Carey. *Courtesy of Wyandot County Historical Society and Museum.*

The back end of the baggage car swung around off the track and landed in the ditch, but the front was still attached to the tender. The tender was completely derailed. The back wheels of the huge engine also left the track.

An overturned stove set fire to the dining car. It being noontime, most of the fifty passengers were in that car. Panic spread as fast as the flames. Men trampled on women and children to climb out the windows of the upturned car. Women grabbed their children and fought to find any exit.

The chef on the train, H. Cole of Cincinnati, was pinned in the culinary compartment of the car. While most of the trainmen and uninjured passengers who were able to climb out went about extinguishing the fire with water and snow, a couple of the trainmen sawed through the side of the car to free Cole.

Farmer Rudolph Haferd lived near the crossing. His wife happened to be outside and saw the accident. She quickly grabbed a ladder and called to her son to come with her. The two ran to help the trainmen rescue the victims who were trapped in the overturned cars. By then, the fire had been put out. The trainmen and uninjured travelers helped to pull the women and children out of the windows and doors. Their job was made harder because some of the windows were locked down.

Mrs. Haferd opened her home to the people who were severely hurt until a relief train could come and transport them to a hospital. Every bed and cot

The Antonia Hospital in Kenton where the injured were taken. *Courtesy of Wyandot County Historical Society and Museum.*

in the house held a victim. The bed linens were torn into bandages. It was noted later by one reporter that the house was a "sight to behold." Even the carpets and walls were stained with blood.

A telephone call to Carey brought the relief train with doctors A.H. Myers, W.G. Brayton, I.N. Zeis, J.M. Harrison, R.C. VanBuren and J.D. Southward. Dr. Moor came from Adrian and was already at the scene. Mrs. Haferd and her daughter did their best to assist the doctors, while her son cared for the unfortunate passengers' belongings.

A majority of the passengers were injured in one way or another. Luckily, most were not greatly impaired. Their traumas ranged from cuts, scratches and gashes to burns and bruises. A number of them were able to continue on to their destinations. Although there were no fatalities, the more seriously injured were loaded onto the relief train and taken to the hospital in Kenton.

Conductor Caskey had internal injuries, as did Mrs. O.W. Heter of Dayton and Bert McKinley of Middletown, Ohio. John Moonshook suffered internal injuries, as well a crushed leg. W.H. Haskin of Detroit fractured his skull and did not recover consciousness for more than twenty-four hours.

Two men, E.C. Ray and R.W. Ray, both from Detroit, and two women—Mrs. Charles F. Evans from Toledo and Miss Pearl Stoner from Albany, Indiana—were taken to the Galt House Hotel. Mrs. Evans wound

up having to stay for several days until her daughter and son-in-law, Mr. and Mrs. W.J. Finlay, could come to Carey to escort her home. Another Toledo resident, George K. Detwiler, who suffered injuries to his hand and foot, hired a rig to take him from the accident scene to Braytod's drugstore in Carey, where he had dressings applied to his lesions.

The superintendent of the railroad, W.G. Bailey, came from Cincinnati to assess the damage. The crossing was open, but the tracks were torn up for several hundred yards. A wrecking train rolled in from Springfield, so by Monday, the wreckage was cleared and the tracks were back in operation.

James B. Dugan, a state railroad commissioner, investigated the accident. It was his opinion that the rails spread because of the freezing temperatures, which caused the dining and day cars to leave the tracks.

Chapter 8

FORTY-THREE SENT TO A FIERY DEATH

The passengers never saw the freight train coming, so they never knew what hit them. Forty-three men, women and children, all passengers on a gasoline-powered Doodlebug rail car, met a fiery death in a head-on collision with a freight train on July 31, 1940, in Cuyahoga Falls. The engineman and two other trainmen—the only survivors—jumped only moments before the crash.

According to Pennsylvania Railroad president E.W. Smith, the Doodlebug was supposed to take a siding ver Lake to permit the two-locomotive, seventy-three-car freight tr pass. For some reason, its engineer, Thomas L. Murtaugh, disre; he orders, opened up the throttle and continued on the main tr ird Akron. Murtaugh also failed to obtain permission from the blo tor at Hudson to go ahead on the single track, Smith told reporters.

Harry B. Shafer of Mount Vernc d been filling in for the Doodlebug's regular conductor, who was on a week's vacation. Shafer's regular run was the Columbus–Cleveland. Just before the commuter car left Hudson southbound for Akron on that hot Wednesday late afternoon, he handed Murtaugh the order for the rail car, known as Train 3380, to open Switch One to take the siding there and meet the freight train with its two engines, 4454 and 4533. "We meet at Switch One. Silver Lake." This was a technical violation, because the operator was supposed to deliver the order to each person who was addressed on the order, most likely the entire crew.

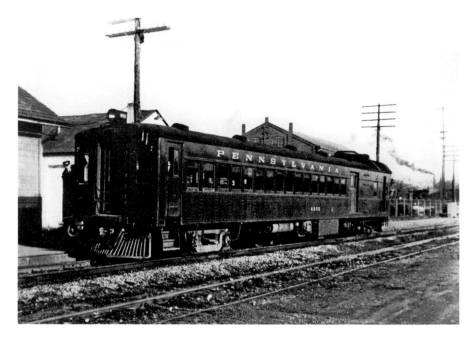

Forty-three died in the Doodlebug that collided with a freight train in Cuyahoga Falls. *Courtesy of the Cuyahoga Falls Historical Society.*

The freight train was on its way to Cleveland from Columbus and was running three hours behind. The conductor, E.R. Collier, had a written order in his pocket that said the Doodlebug would take the siding. The Doodlebug had left Hudson right on time at 5:49 p.m. and was headed south and due into Akron at 6:10 p.m. The accident happened at 6:00 p.m.

Murtaugh decided if he met the freight train at Silver Lake, it would slow him down enough that the B&O train he was to connect with in Akron would have to wait. Apparently, he did not remember anything after that.

Unbeknownst, Shafer was moving down the aisle collecting tickets from passengers in the coach and smoking sections. He then sat down in a seat in the smoking section to do paperwork. When he finished, he looked up and realized the train had gone a mile past Switch One. He immediately knew something was wrong.

As Murtaugh realized he had gone too far, he blew his whistle for Front Street. When he saw the huge double-engine freight coming at him, he acted fast. Taking his hand off the "deadman's throttle," a device that automatically applied the brakes, he released the sander, which dumped sand over the

Front Street and Hudson Drive was the scene of the Doodlebug and freight train accident. *Courtesy of the* Akron Beacon Journal.

tracks to give the wheels traction. He turned off the engine and tugged at the whistle several times. Then he jumped.

Witnesses estimated that the little passenger coach was traveling about fifty-five miles per hour when it plowed into the much slower-moving locomotive about three hundred yards from the siding near Hudson Drive. At the moment of impact, its gas tank, carried on the underside of the car, was punctured and spewed fuel, which caught fire and blew up. Because the passenger compartment was at the front, burning fuel saturated the passengers. Flames shot at least twenty feet in the air, and debris flew in every direction.

The Doodlebug was built so that it did not turn at the end of the line. The engine compartment always faced the north. The engineman prepared it for each trip to Akron by taking the control and brake valve handles out of the cab and inserting them into a control stand at the rear of the car, which was just in front of the passenger compartment.

The freight train was hauling seventy-three cars, thirty loaded and forty-three empty, and a cabin car, so it needed two engines to pull it. During the

collision, the freight train continued to roll forward, pushing the Doodlebug back 537 feet. The first engine on the freight train was telescoped almost a quarter of the way into the Doodlebug's steel construction. The locomotive's pilot, air tanks and smokebox were buried twelve feet into the passenger compartment. One witness likened the wreckage to a melon split with a knife. According to the *Canton Repository*, the coach was "crumpled like wadded paper, for almost half its length." Little damage was done to the first engine, and the freight train was not even derailed.

"We just came around the bend in the road when I saw the gas-electric loom up in front of us," Thomas Lodge, engineer of the freight train told a reporter. He had sustained burns to the side of his face when he jumped to safety. He told the reporter that he jammed on the brakes, but too late. The trains were about six hundred feet apart, and the brakes slowed the big locomotive to twenty-five miles per hour. There was a horrific explosion when the two collided, Lodge said. He and E.N. Reynolds, the train's fireman, "stayed with her through the fire and explosion until she came to a stop, then we jumped through a wall of flame that surrounded the whole wreckage."

Tod E. Wonn, a twenty-four-year-old section hand, had been "deadheading" on the Doodlebug, a term used when a rail worker caught a ride after work on a company car to take him home. He, Bruce Kelly and Hank Peters had been working on a section of track near Hudson when they boarded the coach near suppertime.

"We're not supposed to sit in regular passenger seats when the car is crowded," he said, so the three were riding in the baggage compartment. Hank was curled up asleep, and Tod and Bruce were talking when Conductor Shafer came running back shouting, "We're going to crash!"

"He jumped, and I followed," the young Akron man said. As Wonn leapt out of the car, he felt like Bruce was right on his heels, but he knew Hank was lost. Sparks fell on his clothing. He rolled over and over as he felt the burning ash singe his skin through his shirt and pants.

The first automobile waiting at the Front Street crossing for the trains to pass was a 1935 Buick with Wesley J. Payne behind the wheel. "I was watching the 'gas' engine and did not notice the freight train approaching…I suddenly saw the trains smash together with a terrible crash with the freight engines ramming the 'gas' car," he told Charles M. Conaway, a reporter for the *Cleveland Plain Dealer*. He saw fuel spill out and "soon the trains were a regular furnace with flames bursting forward from every direction." The grass along the tracks was set on fire.

Wesley J. Payne abandoned his automobile at the tracks and ran for cover. He suffered injuries and was hospitalized. *Courtesy of the* Akron Beacon Journal.

Payne's car was hit with flying debris. Feeling the heat of the fire, he was afraid he might catch fire, so he flew out of his car and raced for the river. He said, "People were strewn over the ground." He saw people running in all different directions. He described one man whose back was on fire running toward the river.

Payne said he had fought in France during the World War [I], "but the confusion and turmoil that followed the explosion was more horrible, more ghastly than anything I saw in the war."

Payne tumbled over an embankment, hurting his knee. A stranger helped him up and took him to St. Thomas Hospital, where he had six stitches.

R.H. Martin of Akron was out for a drive with his wife when he saw a huge flash and people running in the direction of the tracks. He told his wife to stay in the car while he ran to see what had happened. The interior of the Doodlebug was engulfed in fire, and flames were shooting out every window, he told a *Cleveland Plain Dealer* reporter. "I saw a girl's charred arm extending from in the flames. All the clothing had been burned from the arm," he said.

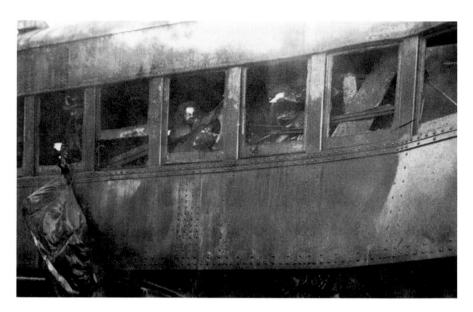

One of the dead in the window of the Doodlebug and a fireman with a body bag. *Courtesy of the Cuyahoga Falls Historical Society.*

Martin saw bodies jammed up against one window, as if they had fought to get out of it. The fire department responded within minutes and began throwing water on the Doodlebug. People were running around frantic, because there was nothing they could do. Police had to push them back and try to rope off the area because they were hampering the rescue attempt.

Martin had his camera with him and jogged around taking pictures. The trainmen warned him and the rest of the crowd that the wreckage could blow up any second, because they could not be sure if the freight train might be carrying something explosive.

Another witness, Ted Housely of Cuyahoga Falls, said the wreck made a rumbling sound, like it was going to fall apart. Instead, it burst into a bonfire. He said, "I saw the thing shoot by the crossing all in flames."

Bodies were hanging from the windows. A veteran police officer standing close by said, "God, this is awful." It was the worst he had ever seen.

One of the first policemen to reach the scene was off-duty state highway patrolman L.D. Alexander from Kent. "I thought the freight train had hit a gasoline truck," he told a reporter. He was horrified to see "people on fire" in a ditch next to the tracks. He yelled to a truck driver to call for help and then he ran back to the wreckage, but the inferno drove him back. One victim

was on the ground, trying to get up, the patrolman said. He made him stay down until he could get an ambulance.

Fire Chief L.P. Seller said, "Flames shot out of the windows." The Cuyahoga Falls fire chief had arrived on the scene only minutes after the explosion. He talked to the *United Press,* and his comments were printed in the *Canton Repository.* His description was the most vivid.

> *The fire was like a screen, and it was almost impossible to see what it was like inside the car. Then, just for a second, the wind parted the flames and I caught a glimpse of the interior. I was sure everybody in there was dead. They must have died almost instantly. I heard no screams at all.*
>
> *Some of the victims were hanging partly out of the windows, and they were on fire. The freight train couldn't seem to stop and it pushed back the "doodlebug."*
>
> *We couldn't do anything at first. Everything was so hot, it was impossible to get near the car. We finally played three lines of water on the fire for 20 minutes before we could get inside the coach.*
>
> *The interior looked as if a tornado had hit it. All the seats were torn loose from their bases and were piled in a heap in the front part of the car. The same thing happened to most of the passengers. They were jammed to the ceiling at the forward end. We had to use acetylene torches to free some of the bodies. Most of them were so charred, they couldn't be recognized.*

The rest of the department got there within minutes with firefighting apparatus and started throwing water on the fire. Within about fifteen minutes, the fire on the outside of the Doodlebug was under control. But the interior burned with fury for at least a half hour before the firemen got it knocked down. They used ladders to shoot water into the passenger coach.

The saddest thing authorities found once the car had cooled down enough to get inside was children smashed under their seats. Men and women were crammed into their seats, pinned by the twisted steel of the front part of the coach. Four passengers had either been thrown from the wreck or had tried to climb out the windows, but their clothing was on fire. Their bodies were found lying along the tracks, still smoldering.

Witnesses said there were no shouts for help or cries of pain. The only sounds coming from the wreck were crackling flames and hissing steam.

When Murtaugh, the engineman of the Doodlebug, was found near the wreck site, he was semi-conscious. He was taken to Akron City Hospital, where doctors listed him in critical condition. Although it appeared that he had jumped clear of the wreck, he suffered a basal skull fracture when

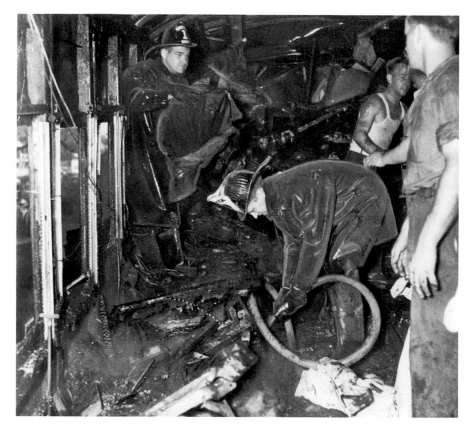

Cuyahoga Falls firemen and rescuers working inside the destroyed Doodlebug. *Courtesy of the Akron Beacon Journal.*

he landed. Doctors said when he talked he was incoherent. Authorities were unable to interview him for a time. His family came from Orville to be by his bedside. He knew Conductor Shafer had been hurt in the crash, but his family and the railroad company kept him in the dark for several weeks as to the extent of the tragedy.

Murtaugh was forty-nine years old, a short man at five-feet-eight and bulky. When he first started working the Doodlebug, he weighed 218 pounds but lost 15 pounds in a short period because he suffered from headaches and had lost his appetite. He had been complaining of smelling exhaust fumes. The day of the accident was especially hot and the humidity was high, which may have made the fumes worse.

When interviewed, Murtaugh said his mind "was a blank" as to why he missed the orders to take a siding at Silver Lake. "I do not remember a thing

The train orders showing Doodlebug engineer Thomas Murtaugh that he was to take a siding at Silver Lake. *Courtesy of the* Akron Beacon Journal.

after leaving Dead Man's Hollow until I saw the freight's engine coming toward us," he told the railroad's division superintendent, F.H. Krick.

Summit County coroner Dr. R.E. Amos brought up the possibility that Murtaugh had been overcome by monoxide fumes from the engine. Krick said he thought fumes had nothing to do with the accident.

Young Wonn was found wandering around, bleeding from a cut on his head and asking about his "buddy." His hands were burned from beating

at the embers on his pants. He was taken to St. Thomas Hospital, where he told doctors that Conductor Shafer had saved his life.

Shafer of Mount Vernon was lying in a bed at the same hospital only a few feet away from Wonn. The fifty-seven–year-old conductor had seriously injured his right hand and foot in his escape. Both were mangled so badly that they had to be amputated. He was given transfusions and kept quiet so he would not know he had lost his hand and foot.

Railroad officials sent word to the sisters at St. Thomas and asked them to retrieve any papers from the pockets of the trainmen's clothing and place them in the hospital safe. An order was found in Shafer's pocket that read "Engine 4454 (freight train) run extra Arlington to Hudson and meet 3380, gas engine 4648 at Switch One, Silver Lake FHK." The initials stood for F.H. Krick, the railroad division superintendent in Cleveland. The order was proof that the Doodlebug crew had received their orders and that it was at fault for the crash and loss of forty-three lives. Coroner Amos ordered the papers impounded until morning when he could start the investigation.

He sent his deputy coroner, Paul Huston, to Akron City Hospital to search Murtaugh's possessions, but Huston found no orders. Railroad men told

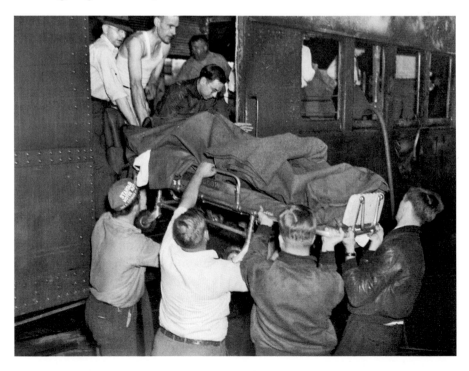

Volunteers removing the dead from the Doodlebug. *Courtesy of the* Akron Beacon Journal.

Sheriff Walter P. O'Neil that engineers frequently placed their orders on a hook in the cab to keep them within eyesight. If that is what happened to Murtaugh's papers, they burned up in the fire.

Engineer Lodge and Fireman Reynolds of the freight train readily produced their orders to meet the Doodlebug at Silver Lake, a mile north of the where the accident occurred. Both men were treated at Akron City Hospital for burns on their faces and necks and released.

Sheriff O'Neil directed a number of his deputies to help firemen, city policemen and volunteers to recover the dead. Stripped to the waist, the men set to work bagging human remains in the humid July air made worse by the heat rising off the wreckage. They needed strong backs to move some of the debris and strong stomachs to remove the bodies as some of the victims were scorched beyond recognition. As darkness closed in, the fire department set up lights so they could see to work. It took two hours to recover the remains.

As the bodies were pulled out of what used to be the Doodlebug, Father Joseph Butler, a young Catholic priest from St. John's Cathedral in

Cleveland, walked among the dead and administered general absolution for the victims. Coroner Amos later determined that nine people died instantly from the collision itself. The rest were incinerated.

According to the *Plain Dealer*, Amos ordered the workers to pile any clothing, pocket books, jewelry, briefcases and glasses in one place. "They may be our only clews [*sic*] to identifying some of the dead," he said. "I don't want to lose anything."

It took about two hours for radio broadcasts to spread the word about the accident—and then the early accounts were not accurate. The first reports indicated that ten lives had been

Father Joseph Butler gave comfort and absolution to the dying. *Courtesy of the Diocese of Cleveland.*

lost. That number increased as the evening wore on. Once the

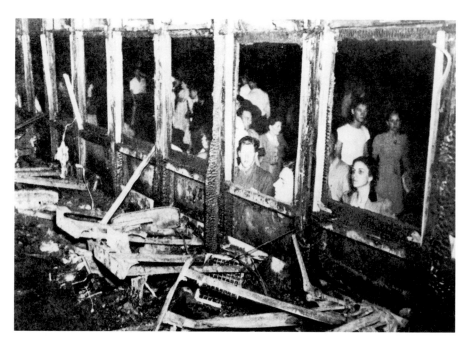

A curious public peering into windows of the burned-out Doodlebug. *Courtesy of the Cuyahoga Falls Historical Society.*

rescue workers were able to cut into the steel hull of the Doodlebug, a definite number for the dead was available.

Hundreds of people from surrounding towns took to their automobiles to go see what had happened for themselves. They filed into the northern area of Cuyahoga Falls to see where the accident took place. The roads became bottlenecked. Traffic was so heavy on a couple roads that it had to be halted so ambulances could get through. Nearly all the roads leading into Cuyahoga Falls were lined with parked automobiles until the early hours. Thousands of people milled around the site. State highway patrolmen, as well as police from Cuyahoga Falls, Akron and the railroad, cordoned off the wreckage and handled the crowd that watched the recovery effort, which lasted until after midnight. In spite of the police presence, someone got up in the cab of one of the freight's engine and lay on the whistle as the body bags were taken from the wreck.

Once all the bodies were removed, another engine was brought in to help clear the track. It was hitched to the undamaged end of the Doodlebug. A wrecker lifted the telescoped end as the freight engines back away. One of the rear trucks (set of wheels) were replaced on the gas car and it was towed away.

By eleven o'clock that night, the train crews had succeeded in clearing the single track. Workers used torches to cut away parts of the Doodlebug so the freight train's forward engine could be separated from what was left of the coach. The freight crew uncoupled some of the freight cars and moved them over to the siding. The two engines were still coupled together while the crew worked at getting the front engine disengaged from the Doodlebug. The steam line on the forward engine was broken, so a second engine was needed to provide power.

When the second engine on the freight train was uncoupled, it gave several blasts of the whistle before it backed away. The sound punched through the darkness in a ghostly way as if a final goodbye to the dead.

In trying to determine the exact cause of the accident, the Interstate Commerce Commission (ICC) cited Public Health Bulletin No. 195, 1936, entitled "Review of Carbon Monoxide Poisoning." It stated that headaches, loss of appetite and sometimes loss of consciousness can be caused by high levels of carbon monoxide in the blood stream. It went on to say that people who were obese were more susceptible than others of normal weight. High humidity and high temperature cause carbon monoxide to enter the bloodstream more rapidly.

The ICC also concluded that there was a strong possibility that Engineman Thomas Murtaugh was temporarily impaired mentally from carbon monoxide poisoning, writing, "A person can be under the influence of carbon monoxide poisoning with a resultant temporary impairment of mental faculties but not be wholly unconscious, and the manner in which the engineman performed indicates the possibility that he was so affected."

Coroner Amos questioned the Ohio Public Utilities Commission whether gasoline was appropriate for passenger trains. He cited the fact that only nine passengers died from the actual accident. The other thirty-four died from the fire resulting from the Doodlebug's gas tanks exploding into flames.

The ICC called into question the Doodlebug carrying 150 gallons of gasoline. "The fact that a car carrying passengers also carried a large quantity of its highly inflammable fuel resulted in increased hazard to passengers and contributed materially to the disastrous consequences of this accident."

The legislative agent for the Brotherhood of Railroad Trainmen, Local 260, George K. Fox, asserted that the wreck could have been avoided if an operator had been on duty at the Silver Lake siding block. He said operators had been removed from the Hudson–Akron run in a company retrenchment program ten years before.

"It seems impossible that men who had been railroading as long as these men had could ignore an order to go to a siding to let the freight train pass," Fox told the *Plain Dealer*. "If there had been an operator at Silver Lake, they could not have passed that block."

The Pennsylvania Railroad said that Fox's query into an operator at Silver Lake would not alter its decision to put the blame on Murtaugh and Shafer. The Ohio Utilities Commission sided with the railroad in placing blame. After surveying the scene and studying the evidence, the commission decided an automatic signaling and remote switch control would have prevented the accident. It gave the railroad approximately twenty days to give reason why such a system should not be installed. An automatic signal would have sidetracked the Doodlebug automatically. The railroad complied and installed a signal at a cost of $100,000.

The railroad started to convert its gas-electric cars to diesel-electric over the next few years. The railroad paid the last of forty-three claims in June 1942. The highest claim was approximately $30,000. The Doodlebug ran its last shuttle from Hudson to Akron on July 31, 1951, the eleventh anniversary of the disaster.

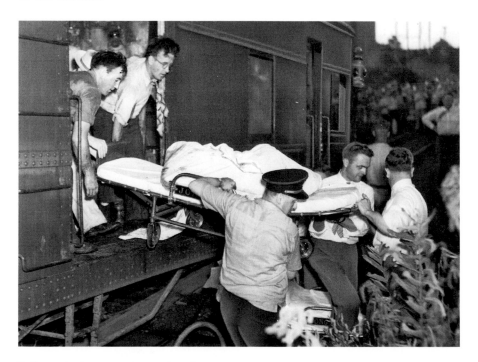

Police and volunteers take the dead from the burned-out Doodlebug. *Courtesy of the* Akron Beacon Journal.

The last survivor of the crash was Tod Wonn. He went to work for Goodyear and retired in 1970. Murtaugh and Shafer both died sometime previous to that.

Chapter 9
DISASTER AT REPUBLIC

In the first bitter days of 1887, Joseph and Mary Postlethwaite and their five children set out to start a new life in Chillicothe, Missouri, where Joseph's brother lived. Having just sold their 180-acre farm near Martinsburg in Wetzel County, West Virginia, for $1,500, the family boarded a train in Bellton bound for Wheeling. At the Baltimore & Ohio depot in Wheeling, Joseph bought second-class tickets to Benwood, where he and his family caught the limited that would take them west.

Kindly conductor Thomas F. Heskett allowed Joseph's wife and three of their children—two boys, one age five and one an infant in arms, and a seven-year-old girl by a former wife—to sit in the ladies' car. Joseph and his two older boys, Spencer, age eighteen, and Henry, age eleven, sat in the smoking car. Their train left Benwood at 7:50 p.m. on Monday. To the Postlethwaites, the trip was probably an adventure filled with hope in a new home. Little did they know their dreams would turn to ashes.

The ride went well until 2:00 a.m. on Tuesday, January 4, when their westbound passenger train No. 5 rammed head on into an eastbound freight train No. 26 just a mile outside of Republic, Ohio. The engines clashed into each other as if in battle, rearing up on their back wheels like great fire-breathing dragons with long tails. The noise shook the countryside, making nearby farmers think there had been an earthquake.

Fire broke out almost instantly in the smoking car from the toppled wood-burning stove and broken kerosene lights. Inside of minutes, it rampaged to the other cars, incinerating anything or anyone in its path. Those who were

not killed outright were trapped by twisted metal, the seats or wooden car parts and awaited death by fire. Shrieks of fear and pain compounded by wailing train whistles pierced the dark air and brought nearby famers.

Jesse Spooner lived within a half-mile of the track and was probably one of the first to the scene and was soon joined by other area farmers. Faced with a horrific sight, they worked like demons to free as many as they could. The trainmen and uninjured passengers tried to help get the others out. But the group quickly saw the fire was rapidly consuming everything in its path. Any attempts they made at rescue were in vain. "Sixteen people lost their lives. Some of them were never identified," Spooner said.

One of the most gruesome sights was a man hanging from the window of the smoker. His legs were pinned inside, and there was no way to get him out. He burned to death, slowly. But before he died he gave his name as M.H. Parks. He was an officer in the Knights of Columbus and lived in Washington, D.C. "I shall never forget," one of the survivors said. "As the flames were creeping closer and closer to him, and he came to the realization that he was doomed to the worst of deaths, he pitched his pocket book to us and gave us his mother's address in Washington." Parks fumbled in his pockets for his valuables and handed them to Lynn Fletcher, the conductor of the freight train. In only moments, the tongues of fire began to lick at him. Soon his charred remains fell to the ground.

The accident happened after Conductor Lynn Fletcher's freight train No. 26 had been sidetracked at the Seneca siding waiting for another westbound train to pass. Passenger train No. 5 was on time and about forty-five minutes away. Fletcher, who had no special orders he was expected to follow, decided not to wait for No. 5 to pass. He figured there was plenty of time for his eighteen-car freight (sixteen cars loaded with barrel hoops, staves and general merchandise and two empty gondolas) train to go to the next siding at Republic, only five miles away. So Engineer Edward S. Kiler gave it the throttle and pulled out of the siding. At that point, the engine had 140 pounds of pressure.

The train had traveled about two miles up the grade from Tiffin to Republic. The conductor was toward the back of the train, but he could tell the engine was slowing down. He started forward to see what was wrong. It took him several minutes to make his way across the tops of the cars that were glazed with ice in the below-zero temperature. They were just west of Republic.

He told reporters that when he got to the engine, "I found that the steam had run down to forty pounds." At that point, he discovered the train was moving only four miles per hour, so he tried to help the new and inexperienced

fireman, W.J. Cullison, stoke the fire. Growing more alarmed by the minute, he looked at his watch and realized they had only four minutes before the passenger train was due.

The front brakeman, Charles Snyder of Columbus, who was in the engine cab with Kiler, noticed only one of the three water gauges was working. Knowing an emergency was at hand, he went to grab the red and white lantern to flag the oncoming train, but Conductor Fletcher snatched it from him and sprang out of the train. Fletcher charged up the track a short distance. Terror stricken, he saw No. 5's headlight and he yelled back to the engineer, "Great God, Kiler, there she comes!"

He hoped the approaching train would see his lantern sooner if he ran to the very outside of the sharp bend in the road. The passenger train reversed his engine, but he was too late. Fletcher looked back at his freight train. It had come to a standstill and was about to meet No. 5 head on. Kiler shut off the steam and leaped out of the cab with the fireman and the brakeman not far behind.

No. 5 was running down the track about sixty miles per hour. It consisted of a mail and baggage car, an express, two sleepers, a smoker and coach. Engineer Lemuel Eastman saw the headlight of the freight engine five hundred yards ahead. He reacted. He gave a shriek of the whistle for brakes and reversed the engine. He then smashed the cab window and jumped from the train, landing in a huge mound of soft snow.

Eastman had yelled to his fireman, William Fredericks, to jump, but he was stoking the fire. Fredericks rose up but hesitated a moment too long. When the engines collided, he was pinned between the boiler head and water tank.

Fletcher would later claim his engineer was drinking. "I saw him take two drinks of whisky at Bloomdale and two at Fostoria (both Ohio)." The final report exonerated Kiler of drinking, stating he had been on the road for sixteen and a half hours with a novice fireman and was worn out.

Harry Forrester of Baltimore was a survivor and gave his account to the press. "I can't tell you much about the way the thing happened. It was quick as a flash," he said. He was not sure how he managed to crawl through millions of splinters and fallen timbers to escape. He was dazed but heard the cries of the injured. "The sights were terrible. There seemed to be wounded people everywhere and all were crying for aid."

Forrester was bleeding heavily from head wounds and was powerless to do anything but get himself out of the wreck. He was close to the baggage master, W.S. Pierce, and the express messenger, who both perished. "There were only four of us, I think, out of eighteen, who got out of the smoking car."

Professor Francis Kendall of Crete, Nebraska, was sitting in the first-class coach right behind the smoking car and just ahead of two sleepers. At first, he felt the sharp application of brakes. The suddenness of the engine reversal violently threw the passengers forward in their seats. "Then came the deafening crash in front of us and our car was shaken up as if by an earthquake," he said.

Shattered glass flew all over the car. He and the other passengers in the coach pushed out of the car and could see the devastation of the whole train. "The baggage and smoking cars were one pile of kindling wood and had already caught fire," Kendall said. He and the other men from the coach tried to help the trainmen rescue others, but the heat was so intense it drove them all back. "There were several persons to be seen in the flames, but they were beyond human help," he said. Some of the victims were still alive, and their screams were dreadful.

Kendall said he helped Spooner try to free Fredericks, the fireman. "I passed the burning cars on the south side," Spooner said later at the inquest. "I saw a man fastened by the leg between the engine and the water tank. I raised his head up; he asked me to raise his body." Spooner said there were several people standing around, but no one would help. "I worked there until the man died, two hours later." A conflicting report stated that the trainmen worked for an hour using saws and axes to try to free Fredericks but with no luck. According to a report in the *Canton Repository*, he was conscious the whole time and died before their eyes.

Spooner overheard Engineer Kiler ask a man from the town if he had seen an "officer of the road." The man said he had, but the officer did not say much about the accident. Kiler said, "I supposed the officials think I am to blame for this wreck, but I am not; I did all in my power to get it in [the freight train], but I could not make my engine work."

Later, the townsman told the coroner, "I thought the engineer of the freight train acted strangely. He seemed awkward and clumsy." Word started to spread that both the engineer and the conductor of the freight train were drunk.

During the coroner's inquest, the front brakeman said, "There is no use in lying; it has to come out somehow. The engineer and conductor of the freight train were both drunk and ought to be hanged."

Regardless of Kiler's remarks and actions, he did participate in the rescue effort by trying to free a man who was trapped between the ladies coach and baggage car.

Another survivor was Fred Betzold, who was from Rushville, Nebraska. He was caught by both legs but managed to wrench himself free just as the

fire reached him. He told Kendall that there was a man sitting on either side of him. Both were jammed in and could not be freed. One of them grabbed Betzold's foot in a desperate grasp and would not let go. Betzold finally kicked free and jumped ten feet to the ground.

A fourth man made it out of the wreck, but no one knew how. He was found lying in the snow with his skull split open. Kendall and Betzold carried him to one of the sleeping cars, but it was doubtful that he would live. For some unknown reason, they thought he was an Irish immigrant.

Survivor William F. Smith from Waynesborough, Pennsylvania, was also riding in the coach nearest the sleepers. He said he did not think there had been a collision but that the train had been derailed. He helped the ladies get their things together and went back to get his hat. "It was then that I saw the fire in the smoker car. I saw an immigrant jump from the car through a wall of flames."

Smith said no one in his car was seriously hurt, although one man burned his hand on the stove. Once he was safely out of his car, he helped others to uncouple the sleepers and push them down the track to where they would be out of the way of the fire.

Smith spotted the little Postlethwaite girl, who was wandering around in a daze. He picked her up and carried her to the depot, where her mother was frantically looking for her.

Mr. and Mrs. Charles P. Toll of Detroit were among those who counted themselves lucky to be riding in one of the sleepers. No one in either sleeper car was injured. When he and his wife got to Toledo, he talked to a reporter. "The two engines were utterly wrecked," he said. "The coach telescoped into the baggage car so completely that the two cars were completely crushed into the space of one." The two cars caught fire from the stove. Toll said, "The mangled and crushed passengers imprisoned in the shattered wreck shrieked in agony as the flames proceeded with their work of destruction."

By the time Toll and his wife left the hideous scene around 5:00 a.m., eight bodies had been recovered. He saw John Gates, the baggage master, being thrown through the roof of his car. Toll thought Gates sustained a broken leg, but he was sure the twenty-five-year-old W.S. Pierce, who was acting as the express messenger, was killed. Gates and Pierce had been sitting together. Gates had been riding with his feet on the floor, and Pierce had drawn his feet up on the seat so his knees were level with his chin. While Gates was hurled in the air, Pierce fell downward and was wedged between the timbers and crushed to death. When Pierce left the express office, he said to his friends, "Well, goodbye boys. 'Til we see

Hearses in front of the Mansion House awaiting the start of the procession. *Courtesy of the Scipio Republic Area Historical Society.*

you again." Twelve hours later, he became a burned-up, unrecognizable corpse. He left a young widow behind.

Gates said at the first impact, the floor under him buckled and sent him upward and then he flew back over the tops of the seats. "I saw the wheels coming through the floor. I passed over men who were being ground to a pulp by a portion of the baggage car." Gates made his escape through one of the windows. He was badly cut up and was sent home to Newark, New Jersey.

One of those men who Gates witnessed was poor M.H. Parks imprisoned between his seat and some timbers. Parks struggled desperately to free himself. "He got himself half way [*sic*] out the window, but the lower part of his body was jammed in. He could not get free." Just before his body was wrapped in flames, he handed his money, some letters and his watch to one of the trainmen. "The watch stopped at 2:02 a.m."

Passenger John Tohill from Chicago Junction, Ohio, (now named Willard) was also in that smoker car one seat in front of Gates. His hair and whiskers singed off, he stood before a reporter and told of his experience. The initial clash of the engines felt to him like he had been hit in the back of the head. Two people flew from their seats to the top of the car, one probably Gates. "Then a horrible crunching and the baggage car came into the smoker through the end."

He added excitedly, "I was caught between the seats, and within a minute fire was raging all around me." It took all his strength to break free and

climb out the window. His face and scalp were blistered, and his shoulder was dislocated.

In spite of the mêlée of fire, wreckage and injured victims, some of the trainmen broke into a hot dispute over who was responsible. One side claimed the freight was on the same time schedule as the passenger train. Someone else was sure he had heard the engineer say he had left the siding with only thirty pounds of steam pressure. (This was untrue. The engine had 140 pounds of pressure when it left the siding.) The passenger crew members argued that their train was not given a proper warning until just moments before the crash.

Personal belongings from the ill-fated trains were found lying along the track as well as in the wreck. One of those relics was part of a shawl pin attached to part of a Grand Army badge, which most likely belonged to Joseph Postlethwaite, who was a Union soldier and belonged to the Seventeenth of West Virginia. Two watches were pulled from the wreck, one gold and one silver. Both had stopped at 2:30 a.m. A third watch, an open-faced silver Elgin, had stopped at 4:00 a.m. on January 4. A ring marked F.P. on the outside was picked up by one of the survivors, as was Martin's card case. Other relics included a set of false teeth, a penknife, a pair of broken glasses, two little stone pipes, a watch charm, some melted gold, a metal sleeve button, keys, clothing, a four-barreled revolver and a metal with a head and the date 1837 on one side and "Dayton Union steam washing, near Fifth Avenue, New York" on the other side. Everything was gathered up and kept in one place for a later effort to identify the dead.

Mary Postlethwaite and her three small children were left destitute. Every penny they had was burned up in her husband's pockets. She walked around as if in a fog, stunned and weak with grief. Someone—she could not remember who—took her and her "babies" to a hotel in Republic. She was grateful for all the attention that the people of the town gave her, but nothing could erase the fact that the man she loved and depended on, the father of her children, had died in such a horrific way.

By noon January 5, what was left of the two B&O engines and the demolished cars had been cleared away. The track had been repaired, and traffic was back to normal. All that was left to show what had happened in the early hours of the day before were a few charred timbers.

The railroad officials wanted to get as many of the passengers away from the scene as quickly as possible before they had to answer any questions. Later that afternoon, they sent most of them by train up to Chicago, where anxious relatives had waited at the station all day. No one had given them

any information about times. The train did not arrive until after midnight and a lot of the relatives had gone home. But the reporters were there to get photographs and stories.

Harry Forrester needed to be helped off the train. His left arm was broken and his head was bandaged. A B&O employee named Burtner, believed to be the stationmaster, roughly grabbed him and pushed him toward a baggage room. As the reporters approached Forrester, Burtner growled at the wounded man, "Don't give your name." He shoved the poor man into the baggage room and locked the door.

"You newspaper fellows are too flip," Burtner barked. "Give it to me if you want to; it will only get me a better job." He got his wish. He was featured in an unflattering picture in the paper the next morning.

Poor Forrester, who had nearly fainted from exhaustion, was finally taken away to a comfortable hotel.

While the disfigured and unrecognizable bodies were being cared for by undertakers, Seneca County coroner Edward Lepper took custody of the bits and pieces of the passengers' belongings. He hoped he could use these sad possessions to try to identify the charred corpses that had once been humans. Telegrams and messages were already flooding into town from frightened families and friends making inquiries about missing people. Soon a flood of relatives, friends and the curious would descend on Republic.

The B&O officials offered to send Mary Postlethwaite on to Chillicothe, Missouri, where she and her family had been headed, but she knew there was nothing there for her. And the smell of charred bodies lingered in her nostrils. She wanted to go home to her mother in West Virginia.

The officials coaxed her to go to a company hotel in Chicago Junction, where she would be "kindly cared for." A disinterested third party talked her into staying at Republic until her stepson could travel up from West Virginia and help her to get back to familiar surroundings. The party also counseled her not to settle right away at the railroad's financial figures.

Coroner Lepper's inquest commenced a week later. He went over the evidence thoroughly. He examined each of the bodies—or what was left of them. He questioned the trainmen, the survivors, the railroad officials and the townsmen and farmers who helped in the rescue effort. He often heard conflicting testimony.

A little over a month later, he presented his findings. The freight train's engine No. 923 was not acting properly and had not been for some time. He wrote in his report that it "was in very bad working order, and in a very dangerous, unserviceable and unsafe condition." He felt that both Engineer

Kiler and the officials were well aware that it was unfit to be running the road. Kiler had called attention to its condition and said "the officials had neglected and refused to put said engine in good repair."

Lepper also found, "The said engineer, Edward S. Kiler, was not under the influence of intoxicating liquors at the time of the collision." The coroner exonerated the engineer by writing, "he had been sixteen hours and fifty minutes continuously on this trip, and he had a new and inexperienced fireman, and that he was greatly overworked and fatigued." He also wrote that Kiler had ample time to make it from the Seneca siding to the Republic siding before the passenger train was due. Kiler could have easily made his run had his engine not "failed for steam." When he left Seneca, he had 140 pounds of pressure, but the engine flues, crown bolts and stay bolts leaked badly. That combination put out the fire, so he could not keep the steam pressure up and so the engine died.

Lepper reprimanded Conductor Lynn F. Fletcher for gross negligence for "being on the engine for at least fifteen minutes before she came to a standstill." Instead of staying aboard the train, he should have sent a flag ahead to warn the coming passenger train. Lepper cited the *Rules to Conductors*, which said that if the main track is obstructed or if the train is moving at an unusually slow rate, for whatever reason, conductors must take immediate action and send their flagmen to both the rear and front of the train and use torpedoes in addition to the regular signals. Torpedoes, usually made of lead, could be strapped on top of a rail. When an engine ran over one, it exploded with a loud bang that could be heard over the train noises. It meant stop or slow down and expect to stop soon.

The brakes on the passenger train were inferior, according to Lepper. If the train had been equipped with automatic air brakes, the collision could probably have been avoided, but Eastman's train had brakes that were obsolete and much less powerful.

In his last finding, and one of his most important points, Lepper said the heating apparatus used on the Baltimore & Ohio passenger train was dangerous in the extreme. He also found fault with the lighting in the cars and found the railroad in violation of the statutes of Ohio in regard to the lighting. The statute read that rail cars may not be lighted with any type of illuminating fluid that could ignite at less than three hundred degrees Fahrenheit.

The lawsuits began shortly after the wreck. The first known to be filed was from Mary Postlethwaite. On January 13, she filed suit against the Baltimore & Ohio Railroad for $25,000.

The company settled with Mary and with all but Mrs. A.B. Ice of Penfield, Illinois. Apparently, the company refused to settle with Mrs. Ice because it did not believe Mr. Ice was even on the train.

Ice was described by the agent who sold him the ticket and by Harry Forrester. Forrester remembered Ice because he carried a bottle and offered him a drink. Coroner Lepper also identified him by his watch and revolver, which were found in the debris of the wreck. Ice was on his way home to Penfield after spending the holidays with friends in the east.

Mrs. Ice was left destitute with three children and another on the way. John K. Rolen, the administrator for her husband's estate, filed the $10,000 suit through attorneys Seney & Schaufelberger in July. No documents were left to tell whether she won the suit or whether the B&O finally settled.

One night, just two months after the wreck, the No. 5 passenger train with a new engine and different crew were approaching the spot where the previous No. 5 had wrecked with the freight train. The engineer saw a red light, the danger signal, up ahead. He applied his brakes and reversed his engine, bringing his train to a standstill. He and his fireman peered out into

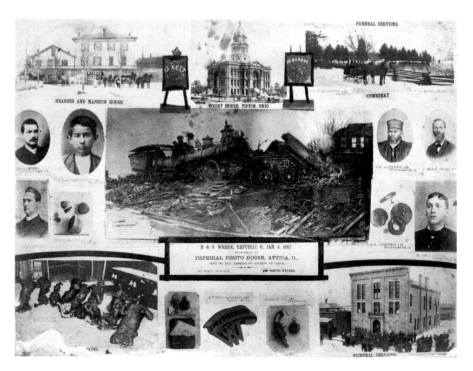

A cabinet card with scenes that include burned bodies, items found near the wreck, the town hall and the cemetery. *Courtesy of the Seneca County Museum.*

the dark. The light was gone, but they swore they saw a woman dressed in white carrying the lantern. The conductor got down from the train and walked the track ahead for some distance but saw nothing unusual. The crew went back to the Republic station and questioned the operator, but he said no signal had been sent out. According to people in that area, the apparition had appeared on three separate occasions. People watched that spot for several nights, but the lady in white never reappeared.

Others tell of a ghost train that can be seen from the Farewell Retreat Cemetery where the unidentified passengers had been buried in a common grave. They claim its headlight glows eerily as it races over the trestle.

Chapter 10
DEATH IN THE DARK

Death rolled into the slumbering village of Lindsey, Ohio, shortly after 10:00 p.m. on Saturday, August 5, 1893. It came in the form of the Pacific Express No. 9. Belonging to the Lake Shore & Southern Michigan Railway, the train was made up of the engine, three baggage cars, two express cars, three coaches and five sleepers. The sleepers were loaded with weary, unsuspecting travelers, including the Chicago Colts baseball team. Its passengers may have been bound for the Chicago World's Fair, but they ended up in hell.

Lindsey rests in Sandusky County, about eight miles west of Fremont in the northwestern part of Ohio. Its population was only about 500 in the 1890s. In modern times, the inhabitants number around 450.

As No. 9 thundered into Lindsey running ten minutes late at a high rate of speed on that summer night, it approached a siding where No. 74, a local freight train eastbound from Toledo to Cleveland, sat waiting for it to go by. The idle train's engine and thirteen of its cars had been uncoupled from the rest of the train. No. 9 began to pass by safely. But when the first sleepers, the Erie, Oronocco and Oscawana, got close to the freight at the switch, they swerved from their course, jumped the track and hurled into the engine of the freight train. The engine spun around and overturned.

The collision killed the freight train's engineer, Ed Lafferty from Elyria, and its brakeman, Charles Spane from Clayville, New York. Lafferty left a wife and four children behind. A porter, J.R. Robertson, from the sleeper Erie was also killed. He was from Chicago. Lafferty and Spane were found together, crushed beneath

the engine. Robinson's body was recovered from the ruins of the Oronocco. All three men were killed instantly. Their bodies were found the next day around 6:00 a.m. Undertaker John Boyer prepared the remains for burial and to be shipped to their homes. According to a report in the *Cleveland Leader*, "The bodies were in horrible condition and presented a most sickening sight." Limbs were cut off, and heads were mashed until they were unrecognizable.

The sight was horrific. The engine of No. 74 was a hulking wreck, hissing steam. The Oronocco was reduced to tinder and broken glass. The sides of the other sleepers and coaches had been ripped wide open. It was a miracle any of the travelers inside were left alive. A carload of flour on the local freight was also demolished. The sleepers, made by the Wagner Palace Car Company, were reduced to twisted steel and splintered wood. Their debris covered the tracks and surrounding ground.

The train crew and citizens of Lindsey immediately began digging for survivors

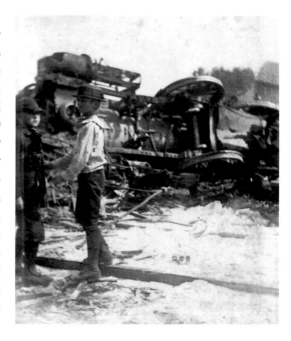

Boys at the overturned locomotive in 1893 at Lindsey. *Courtesy of the Harris-Elmore Public Library.*

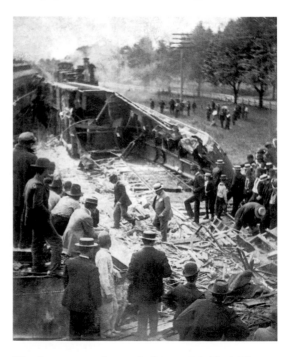

The sleepers were destroyed. *Courtesy of the Harris-Elmore Public Library.*

Jimmy Ryan, center fielder for the Chicago Colts, was injured in the train wreck at Lindsey. *Courtesy of the National Baseball Hall of Fame Library, Cooperstown, NY.*

in the ruins of the sleepers. Arms and legs protruded from the carcass of the wreck while groans and cries emanated from deep within the tangled mass. A medical party of six from Fremont—including Drs. Williams Caldwell, F.U. Hilbish, M. Stamm and R.B. Meck—hurried to the site and began to care for the injured.

Jimmy Ryan, the center fielder for the Chicago baseball club, was badly cut up and bled profusely. The ball club's catcher, Malachi Kittridge, also suffered lacerations about the head and on his body. Both players were listed as seriously injured. Other ball players suffered minor cuts and bruises.

Chicago Colts catcher Malachi Kittridge was injured during the train wreck at Lindsey. *Courtesy of National Baseball Hall of Fame Library, Cooperstown, N.Y.*

Luckily, Ryan, Kittridge and their teammates were riding in the last sleeper, or they might have been killed.

Those with more serious injuries were taken to the Hotel Nichols, while other victims were looked after in private residences. Some of them were listed in the *Cleveland Leader*.

A professor from Amherst College in Gloucester, Massachusetts, suffered a crushed chest and, at first, was not expected to survive. His condition did improve, however. A Pittsburgh man had internal injuries and was near death's door for a few days until he began to rally. Two more porters were in serious condition. An Allegheny City, Pennsylvania man lost his left foot.

Fifteen to twenty people with less serious injuries were treated for cuts and bruises and were able to continue on their journeys on the part of No. 9 that had escaped damage.

A wrecking train arrived around 3:00 a.m. the next day and began to clear the tracks. Lake Shore officials came to the site at noon on a special train from Toledo. They examined the track and ascertained that the heavy weight of the sleeping cars, filled to capacity with passengers, caused the rails to spread.

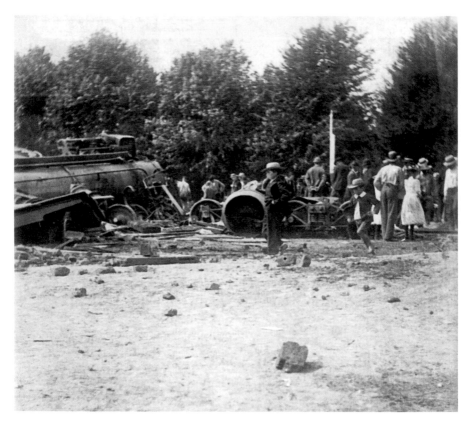

Children playing near the Lindsey train wreck. *Courtesy of the Harris-Elmore Public Library.*

The Wagner Palace Car Company's loss was substantial. The Lake Shore company lost an engine and two cars. The destruction was so extensive that it was a wonder more lives were not lost.

The Chicago Colts won fifty-six games that year and lost seventy-one.

Chapter 11
TRAPPED IN A CALDRON OF STEAM

C uriosity killed the cat, but it saved the lives of Alvin A. Van Dorsten and three of his friends on Tuesday evening, December 3, 1912. He and fellow traveling salesmen Albert Tway and Harvey Daringer, all three of Zanesville, and C.H. Truscott of Cleveland were passengers on the Cleveland, Akron & Columbus (CA&C) train No. 125 when it was rear-ended by a Cincinnati & Muskingham Valley (C&MV) passenger train No. 43.

Both trains were westbound and, according to a *Plain Dealer* news account, should have been rolling at least ten minutes apart for the seventeen-mile trip from Trinway to Zanesville on the Pennsylvania system, but both were behind schedule, and so that time gap was ignored.

The salesmen were close to their destination of Zanesville when their train, consisting of engine No. 9828, pulling a wooden coach and wooden combination mail, baggage and express car, came to an abrupt standstill. It was on the main track three and a half miles below Dresden. Van Dorsten and his friends stepped out onto the rear platform to see what was happening. They saw the train's position was on a curve about a mile above the Rock Cut. It was approximately 5:55 p.m., dark and clear.

One of the pipes that supplied the air-whistle signal with air from the main air drum had broken, causing the air brakes to be automatically applied. It was no surprise to the engine crew members, because the night before they had reported that the pipe needed some repairs, but nothing was done because the repair parts were not available.

The crew quickly started trying to make repairs, as a wild-eyed flagman, George Coon, came racing up the track to flag the C&MV train that had left Dresden only minutes after the disabled train. Coon had lanterns and torpedoes in hand to try to protect his train but no fuses. "He had just reached a curve about three hundred feet away when we heard the other train coming," Van Dorsten told a *Canton Repository* reporter when he was interviewed two days later.

C&MV engineer James Bryant at first did not see Coon. When Bryant did see him, he quickly made a ten-pound reduction on his air brakes. Then he saw the warning markers! Instantly, Bryant shoved the brake valve into the emergency position and reversed the engine.

On the back platform of No. 125, one of the salesmen yelled, "For God's sake, jump! They can't stop in time!"

"When we saw the reflection of light of the engine coming around the curve, one of us jumped," Van Dorsten said. "The train must have been coming fifty or sixty miles an hour. I was the last to jump, and the engine was within ten feet of me when I landed."

Van Dorsten's estimate of the approaching train's speed was close to accurate, because trains often attained sixty-five miles per hour on that downhill, straight stretch of track. However, according to the time-card rule, the speed limit for trains on that section of the road was forty miles an hour. It was well known that engineers generally did not follow this rule.

Truscott claimed to have a premonition of the wreck when he left Trinway. "I told another 'knight of the grip' [traveling salesman] that something was going to happen."

The speeding locomotive No. 9713 plunged into the stopped train with terrific impact. Van Dorsten recalled the sounds of the crash. "The air was filled with the sounds of crackling wood, the hiss of escaping steam and the cries of trapped passengers in the coach." Because he landed so close to the wreck, he was amazed that he was not hit by huge pieces of wood and flying splinters.

"By the time I looked up, the engine of the rear train had plowed its way clear through the passenger coach," he said. "The darkness added to the horror." He dug his way out from underneath the debris and began helping some of the victims.

Engine No. 9713 hit with such force that it drove the CA&C train two or three hundred feet ahead. It split the opposing train's coach completely in two so that its sides fell to both sides of the track. Although the C&MV locomotive sustained considerable damage, none of the trucks (wheels)

derailed. It had been hauling two coaches and one combination mail, baggage and express car. Two of those cars were somewhat damaged.

The accident occurred in an isolated area, so it took twenty minutes for help to be notified. In the meantime, the trainmen built bonfires alongside to track and made cots for the injured from train seat cushions. The uninjured passengers immediately began to pull passengers out of the windows. One of them cried out, "Save the women first!"

The first person Van Dorsten saw was a woman lying on top of the steaming engine. Her screams were gut-wrenching, as she was literally being cooked. Another news account stated that she was found with her head jammed through the window. Whichever grotesque fate she suffered, she died a few moments after being brought down to the ground. She was later identified at the undertaking establishment in Dresden as thirty-two-year-old Mrs. Daisy Mae Emerson of Zanesville. She and her two small children, two-year-old William Burgy and three-year-old Sarah Elizabeth, were in seats near the rear end of the coach. Both children were dead.

Daisy's father, fifty-four-year-old Jacob Burgy, was found in the seat opposite where she and her children were sitting. He was alive but scalded about the face and chest. He lived for twelve hours before succumbing to his injuries at Zanesville's Good Samaritan Hospital. He was part owner of Ohio Pottery.

The young mother, her children and father had been visiting relatives in Clinton and were on their way home. Daisy's mother, Anna Burgy, had opted to stay in Clinton for a longer visit.

Van Dorsten described how one of the victims, a man, was hanging out the window, struggling to kick his feet free. They were pinned under the engine. "We cut the wood away and took him out," Van Dorsten said.

The scene underneath him was even worse. They found Nellie Schumacher Taylor, who was badly bruised and burned. The twenty-eight-year-old Zanesville woman was a seamstress who would later pass away in the Good Samaritan Hospital. Next to her was a man who had been crushed to death. He was the only victim who had not been scalded to death.

The men who had not been injured tore off their coats and wrapped the victims against the cold. "The scene was past description," Van Dorsten told the *Repository* reporter. Van Dorsten had come down with a cold due to giving his coat to one of the victims. "Those who were conscious begged for water, while others prayed that we would kill them."

A C&MV engineer, Tony Groff, and carpenter, Grant Hasson, were "deadheading" (riding home from a work assignment or to an outlying terminal

Prospect Place where some say victims of the Dresden train wreck were taken. *Courtesy of James A. Willis, Director of The Ghosts of Ohio.*

where they would go on duty) on No. 43. They used axes to tear away debris and risked their lives to crawl through the caldron of steam and smoke. They were later nominated for Carnegie Medals for their heroism.

While waiting for a relief train from Zanesville, which carried railroad officials and doctors, rescuers did what they could for the victims. The Haunted History Columbus blog (August 2010) states that the cellar of the nearby Prospect Place Mansion (also known as Trinway Mansion) was said to have been used as a makeshift hospital until the relief train arrived, but there seems to be no substantial evidence to that.

The mansion is a popular place for ghost hunters, with the most active specters being a runaway slave girl and a bounty hunter. There are tales associated with crash-victim ghosts, but they are vague and not tied to any particular room in the house.

When the news broke in Zanesville, thousands flocked to the depot. Residents knew both trains were due into their city and that most of the passengers on those trains were from the city. Panic grew as they waited. Finally, at 9:10 p.m., the relief train rolled into the station, carrying the live, dead and injured victims. The crowd swarmed its doors, making it hard for the uninjured passengers to debark. Cries of relief filled the air as loved ones

In the doorway, George Adams, executive director of G.W. Adams Educational Center Prospect Place. *Courtesy of James A. Willis, Director of The Ghosts of Ohio.*

hugged, and tears of agony fell when some learned of their loved ones' fates. Ambulances began to load the injured to rush off to the hospitals.

One of the most seriously injured was a thirty-year-old salesman from Lodi named Max Harris. He was traveling with a fellow salesman and Sigma Chi fraternity brother, thirty-five-year-old Henry Bartles from Albion, Michigan. Lying in a hospital bed, Harris asked if he was going to live. Sadly, he was told that he had no hope. He told his doctors that he was engaged to Miss Julia Rodman of Paola, Kansas, and he asked if they would notify her. He died within an hour of his friend Bartles.

Henry Balbian, the best-known woolen-mill man in the country at the time, was found on top of the engine boiler. The fifty-eight-year-old had lived in Cleveland for many years but managed a branch of the Cleveland Woolen Mills in Dresden. His wife hurried to the hospital as soon as she got word that her husband had been seriously injured. Unfortunately, he died before she got there.

After two days, one body that had been scalded so badly still could not be identified by sight. A letter in his belongings was written to the Agricultural

Chemical Company and contained the names O.N. Rittenhouse and F.M Sears. It set out information on a lawsuit that was to begin the next Saturday. The letter was covered in blood and soot and was almost illegible. Using the letter, the authorities finally identified him as Henry J. Haskell, a traveling salesman from Zanesville. He was well known all over Ohio as a "loader of the Gideons."

The body count climbed to eleven, with five seriously injured. The first three bodies were prepared for burial and shipped to their various homes and families.

To add to the Emerson and Burgy family tragedy was the fact that Albert Bacon Emerson (Daisy's husband) was away on a business trip as a salesman at the time and could not be reached. He was in Saginaw, Michigan, and learned in the morning newspaper that his whole family had been wiped out. He boarded the first train to Zanesville and got home the day of the funeral of his wife, children and father-in-law in Clinton.

A few days after the wreck, the Ohio Public Service Commission and the Interstate Commerce Commission began to probe the incidents that led up to the accident. What they discovered was a compilation of events that contributed to the accident.

The commissioners held the Pennsylvania Railroad, owner of the CA&C, accountable for failing to maintain Engine No. 9828 when it was known that the air brake system was in need of repair.

Chief inspector of safety appliances for the Interstate Commerce Commission H.W. Belnap attributed the direct cause of the accident to Flagman George Coon not being able to protect his train adequately. Coon kept the emergency fuses in the train box in the smoking compartment of the coach instead at the rear of the train, where he could grab one and light it fast. Belnap noted that Coon knew No. 43 was following closely behind his train and should have had his fuses at the ready. If the fuses had been in the proper location, Coon could have taken one with him when he set out to flag the oncoming train.

Belnap wrote in his report that Conductor C.L. Sapp, who was in control of the CA&C train, should be held responsible for not seeing to it that all the stop signals (flags, fuses, torpedoes, etc.) were in their proper place.

As No. 43 sped down the track, its fireman, James Sunderman, was shoveling coal and did not see Coon. Engineer James Bryant also missed seeing the flagman at first. The commission found that Bryant was traveling above the speed limit as set forth on the time-card rule for that section of the track. If he had been traveling at the allotted speed of forty miles per hour,

he might have seen Coon in time to stop his train before the calamity. Bryant suffered severe burns and cuts.

Passengers on the C&MV train stated that their train left Trinway station approximately three minutes behind the CA&C train. The Dresden operator, Fred Smith, confirmed that he received release orders from the C&MV Zanesville division office for No. 43 a spare three minutes and forty seconds after No. 125 had left the Trinway depot.

Commissioner John C. Sullivan of the Public Utilities Commission told the *Cincinnati Post*, "There seems to be no doubt but that the two trains that collided were following each other with the space of only a few moments between. This condition must be remedied as well as the bad flagging, which causes the majority of wrecks."

Belnap cited Rule 91, which stated how closely trains could travel together: "Unless some form of block signal is used, trains in the same direction must keep at least five minutes apart except when closing up at stations."

He wrote in his February 18, 1913 report:

> *This rule provides proper spacing of trains only in the vicinity of open stations. Should these open stations be far apart, a fast train could easily overtake a slow train, while should a train come to an unexpected stop, as was the case in this instance, it might be impossible for the flagman to go back the distance necessary to protect his train. This rule is believed to be entirely inadequate to insure proper protection.*

In the end, the accident took the lives of nine passengers and two railroad employees and injured three passengers, three employees and one mail clerk. An account in the *Adamsville Register* claimed the accident cost the Pennsylvania Railroad upward of $500,000.

Chapter 12
ONE OF THOSE UNGODLY FREAKS

O ne of Those Ungodly Freaks" is what a New York Central System official called the rail catastrophe that happened on the company's tracks on a rainy night in 1953 at the Ohio-Pennsylvania line near Conneaut. The March 23 pileup of a freight train and two passenger trains cut short twenty-one lives and sent sixty-six people to the hospital. Another forty-five to fifty-five people on those trains were given first aid. An unsecured load on a second freight that had passed through that spot only minutes before caused the freak accident.

Around 9:18 p.m., an eastbound freight train passed slowly through Conneaut where the conductor had received and acknowledged a "Proceed" signal from the agent there. The signal indicated that nothing defective was observed on the conductor's train. Down the road, the train crawled through "state line curve" at thirty-six miles per hour. The freight consisted of a helper engine and a two-unit diesel-electric road locomotive. It hauled 103 cars and a caboose.

State line curve consisted of four tracks. The two inner tracks were for passenger trains, and the two outer tracks were for freight trains.

The crew of the eastbound freight was unaware that one of the gondola cars, which was carrying fifty-eight pieces of pipe, let loose some of its lading. At least nine of the pipes fell onto the westward passenger track, knocking one of the rails out of alignment.

At 10:00 p.m. and right on schedule, the Buffalo-Cleveland westbound freight train consisting of two diesel-electric engines coupled in multiple-unit

control, hauling 120 cars and a caboose came around the four-track state line curve lumbering along at thirty-one miles an hour. The brakeman, J.R. Shadduck, noticed some sparks coming out from underneath the eastbound freight as it passed him. He "swung it down" (signaled it to stop). Crew members later would testify that one of the cars, a gondola, carried a load of steel pipe bound for New York. They found nine pieces were missing from the load. The car was left behind at Springfield, Pennsylvania, a short distance from state line curve.

Westbound first-class passenger train No. 5, sometimes called the Mohawk, traveling from Buffalo to Chicago, was also on time. At one minute after ten, it roared into the curve with two diesel-electric engines coupled into a multiple-unit control doing seventy-six miles an hour. It pulled a mail car, two express cars, a baggage car, two coaches, three sleeping cars, a combination club-sleeping car and an observation-sleeping car.

No. 12, the Southwestern Limited, was a first-class eastbound passenger train en route from St. Louis to New York. It was due in at 10:02 p.m. It hit state line curve doing seventy-one miles per hour right on time. It had the same engine makeup of two units, and it pulled a combination baggage-dormitory car, three coaches, a dining car, six sleeping cars and an observation-sleeping car. Between the two flyers, there were 309 passengers.

The engineer of No. 5 observed the safety rule of dimming his powerful headlight in order not to blind the oncoming engineer of No. 12. At that same moment, he spotted a kinked-up rail. There was not much he could do to slow his train, but he applied his brakes and sparks flew.

Sixty-year-old Elwyn Green was at the throttle on No. 12. He said he saw No. 5 heading in the opposite direction, and that sparks were flying out from its brake. Green spotted the obstruction on the track and "then came the crash." It was the first wreck of his long railroad career. He was treated for shock and a broken finger.

The Mohawk's engine and the first ten cars derailed immediately and crashed into the slower-moving westbound freight, derailing fourteen of its cars. The passenger cars spilled over onto the track in front of the fast-moving No. 12 eastbound passenger train. The collision was immense. The engines and first nine cars of the eastbound passenger train No. 12 were derailed. Nineteen of the steel-constructed cars were demolished or horribly damaged. At least two of the engines were destroyed or badly impaired. A thousand feet of track was torn up, and communication lines were cut down by flying debris.

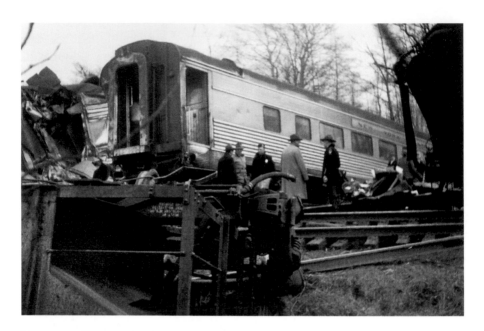

Twenty-one lives were lost in this three-train pile-up near Conneaut. *Courtesy of the Conneaut Railroad Museum.*

But the worst cost was in human life and limb. The assistant conductor and the brakeman of Mohawk No. 5 were killed. The brakeman, James A. Lewis, was a twelve-year veteran of the rails with the New York Central. He was from Cleveland and married with four very young children.

Four other people from Cleveland lost their lives, including an occupational therapist, twenty-seven-year-old Edna Marie Ryan. She dedicated her life to the physically impaired because she, herself, had lost a leg when she was only seven. James H. Shuh died while returning home from a long business project. He was forty-one, married and had two grown children.

Twenty-four-year-old Donald C. Ashton had only been married a few months when he was killed. He was the second mate on a freighter for a shipping company. He was on his way back to his new bride and a new home that the two had just purchased.

A young Western Reserve University graduate student named Vaughan A. White also died in the accident. He was with two friends, who were injured.

Fifteen others from all over Ohio, New York, Pennsylvania, Illinois and Louisiana went to their deaths that night.

The wreckage lay in a desolate mud-soaked area among thickets and woods. Because the wreck itself had snapped off communication poles, one

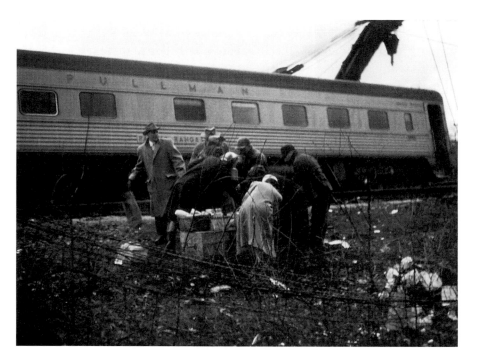

Workers clearing the tracks at "state line curve" near Conneaut. *Courtesy of the Conneaut Railroad Museum.*

of the conductors ran three miles to get help. The site was two miles off heavily traveled Route 20, so it took nearly an hour for rescue workers to get into the area.

A nine-car relief train carrying medical personnel and supplies, as well as a contingent of the Red Cross, started toward the wreck from Cleveland. Erie sent its own mercy train.

The owner of the State Line Service Center, Tony Talarico, told the papers, "The first I knew of the wreck was when a fifty-year-old conductor walked in and said, 'Call somebody.'

"I sent one of my boys, Bob Lash, over to the restaurant next door. He started calling people from there while I called people from here. I told the operator to turn in an emergency call. Let everybody know."

One of the first people to reach the wreck was Andy Aranyons, an employee of the State Line Service Center. "There was no panic among the passengers when I got there," he told a *Plain Dealer* reporter. "I walked around and saw a Catholic priest. Then the two of us started going through the cars."

"I helped carry out at least ten dead," Aranyons said. "We just put them there on the ground and left them there covered." He told the reporter there were so many injured, and at first, he and the priest could not get any help from the passengers.

"In one car, I found two dead. Then I walked around the car in the mud and heard people crying in another car." Aranyons found another dead body and five injured in that car.

When Talarico got to the wreck, he said the bodies were all mangled. "The dead were strewn all over the tracks. Telephone poles are down."

Aranyons and the priest walked up the tracks. Finally, they heard sirens off in the distance. After awhile, state police from Ohio and Pennsylvania came slogging through the mud toward the train. They immediately started to evacuate the wounded. Medical teams followed behind them. "The doctors were giving drugs to the badly injured people. Then some more people started to help out with the injured."

The Red Cross arrived and set up an emergency first-aid station. Minor scrapes and cuts were treated on the spot, but the more seriously injured had to be carried out on stretchers and in handcarts down a rutty lane a quarter of a mile to ambulances that waited on the hub-deep muddy road. So many people were injured that the rescue team ran out of stretchers. After that, they started using the window shades.

"It was just like being in hell," said passenger George Sapaceanu, a furrier for I.J. Fox Company of Cleveland. He; his wife, Emily; and their six-year-old son, George Jr., had been passengers on No. 12. They were on their way to New York to visit their married daughter. He said they felt a tremendous jolt, and then the lights went out. "Women and children started screaming their brains out. I'll never forget it," he told a *Plain Dealer* reporter by phone.

Sapaceanu said it was so dark that it was almost impossible to see. He and others broke out windows to let air in. Someone came through the car and warned passengers not to light any matches. "You could smell oil in the air," he said. He and others managed to carry the women and children to the coaches that had not been damaged. "I guess I carried two dozen of them and all the time I was doing it, I prayed to God to help those poor, poor people who were just lying there suffering."

The forty-one-year-old Sapaceanu sobbed as he talked of the horrific scene. Grown men fainted at the sights that surrounded them. Some of the passengers just sat stunned and stared straight ahead as if they were in a trance, he said.

He and his family were treated at Hamot Hospital in Erie for cuts and bruises. They were released soon after. "I'll never stop thanking God for protecting my family."

Richard H. Willis of Cleveland Heights counted himself lucky that he did not get the seat he wanted "up front" in a coach on train No. 5 on that Friday evening. When there were few vacant spots left, the twenty-two-year-old engineer for Bell Aircraft had to settle for a seat at the back of the car. He was on his way home from Buffalo.

The ride from Buffalo was smooth as he sat looking out the window until near Conneaut. "I felt a jar," he told reporters. "There was no warning, and there were no brakes." He had a feeling there might be a wreck, so he dove for the floor right before the eastbound train No. 12 hit. It all happened so fast, and the people in his car were tossed around like rag dolls.

The rear of the car where he was sitting suffered little damage, but the front—where he had wanted to sit—was nearly demolished in the collision. "A car from the other train was jammed up against the right side of ours," he said. Some of the people in the front of the car were pinned under a jumble of luggage and seats that had come loose from their bolts. He said the porter's hand went through the window and into the car of the other train, and he was caught there. The entrance to the car was caved in, trapping the passengers. Willis's window turned out to be the only one that would open and allow them to escape.

Willis may have mistook the assistant conductor, G.W. Lockwood, for the porter. Lockwood injured his hand in a similar incident as he was walking down the aisle from the front of the coach to the back. He told the *Plain Dealer* that he was wrapped in steel partitions with another man who died as they lay there together. He heard voices outside and recognized the engineer's. Lockwood yelled to him. The trainmen scrambled to pry him loose from the wreckage. He wound up with the tips of two fingers being amputated.

Olmsted Falls police chief J. Donald Shirer was on the Southwest Limited No. 12 en route to Erie for a coast guard meeting. Just before the crash, he ducked down behind the seat in front of his. Luckily, he had his trusty flashlight with him. It came in handy as he searched for victims in the dark. He described the car he was in as chaos. In spite of being injured himself, he attended to one woman who had blood pouring out of her left side. "I tried to staunch the blood with her clothes, but she died in my arms," he said. Then he helped take out four dead people. Shirer was later taken to Hamot Hospital.

Ten-year-old Emanuel Irby may have owed his life to his grandmother. When the collision happened, Rosetta L. Jordan shielded her grandson

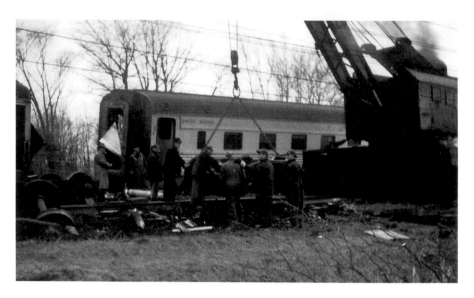

It took six days to clear the wreckage and restore the tracks from the freakish accident near Conneaut. *Courtesy of the Conneaut Railroad Museum.*

with her own body. Rescuers pulled the grandmother and her grandson out of the wrecked car through a window. The child was uninjured, but Mrs. Jordan fractured her femur and injured her back. She lost all of her clothing and $125 in cash.

Frederick Peckman of the Bronx told an *Associated Press* reporter that no one in his coach was badly hurt. He and the other passengers were stuck in their car for at least four hours before rescuers got to them. He described a scene of injured people either walking or being carried past his car. "Instead of a lot of fuss, it seemed like almost everything was too quiet. It kind of got on my nerves after awhile."

It took state police, firemen, trainmen and volunteers twelve exhausting hours to sort through the tangled ruins in the rain. They cut the twisted steel with blowtorches and saws to remove the injured and dead and look for other victims.

After that, a crew of four hundred men and five wrecker trains spent six days working day and night to restore the track to full service. The total cost to the railroad was between $2 million and $3 million.

Five days after the accident, the Interstate Commerce Commission called a public hearing at Erie. Commissioner W.J. Patterson and Examiner E.J. Hoy conducted the investigation. They found that the load on that particular gondola was not properly secured because the high-tension bands were not properly sealed.

A portion of the load—nine pieces of nine-foot-long, eighteen-inch-diameter pipe—dropped from the car while it was in transit and damaged the westbound passenger track, which caused No. 5 to derail into the side of the westbound freight, causing it, in turn, to derail. No. 12 plowed into the two derailed trains before the disabled equipment could be protected.

The FBI also had a look at the wreck for signs of sabotage but found nothing to suggest foul play.

The wreck came shortly after the nation's railroads claimed to have had their safest year ever. The railroads saw no passenger deaths in 1952.

SOURCES

NEWSPAPERS AND NEWSLETTERS

Adamsville (OH) Register.
Akron (OH) Beacon Journal.
Amherst (OH) News-Times.
Amherst (OH) Reporter.
Amherst (OH) Weekly News.
Brazil (IN) Democrat.
Canton (OH) Repository.
Carey (OH) Times.
Chicago Tribune.
Cincinnati Daily Times.
Cincinnati Post.
Cleveland (OH) Leader.
Cleveland (OH) Plain Dealer.
(Covington) Kentucky Post.
Interstate Commerce Commission Report, February 18, 1913, April 25, 1916.
Lima (OH) News.
Logansport (IN) Weekly Pharos.
Lorain County (OH) Chronicle-Telegram.
Lorain County (OH) Morning Journal.
Lorain (OH) Daily News.
Lorain (OH) Journal.
Newark (OH) Advocate.

SOURCES

Newark (OH) Daily Advocate.
New Philadelphia (OH) Times Recorder.
New York Tribune.
Portsmouth (OH) Daily Times.
Researcher: A Family Heritage Newsletter.
Sandusky (OH) Register.
(Springfield) Daily Illinois State Journal.
Springfield (OH) Daily Sun.
Steubenville (OH) Daily Herald.
Westville (IN) Indicator.
Wyndott County (OH) Daily Chief.

BOOKS AND MAGAZINES

The Amherst Business and Professional Women's Club. *Amherst Reflections.* Elyria, OH: Wilmot Printing, Inc. with cooperation of the Elyria Chronicle Telegram, 1976.

Bruce, John. "It Was the Most Horrible Sight…" *The Keystone* 39, no. 1 (2006): 47–55.

Frizzi, Daniel L., Jr. *An American Railroad Portrait: People, Places and Pultney: A History of the Development of Railroads in Pultney Township of Belmont County, Ohio, and in Particular the City of Bellaire.* Wheeling, WV: Daniel L. Frizzi Jr., by Boyd Press, 1993.

Seguin, Marilyn, and Scott Seguin. *Images of America: Cuyahoga Falls, Ohio.* Chicago, IL: Arcadia Publishing, 2000.

Turzillo, Jane Ann. *Images of America: Hudson, Ohio.* Chicago, IL: Arcadia Publishing, 2002.

Willis, James A. *The Big Book of Ohio Ghost Stories.* Mechanicsburg, PA: Stackpole Books, 2013.

WEBSITES

Ashtabula Bridge Disaster Page. home.windsteam.net/arhf/bridge4.htm.

Ashtabula River Railroad Disaster. 35wbridge.pbworks.com.

Christian Biography Resources. www.thewholesomewords.org/biography/biobliss5.html.

GenDisasters: Events that Touched Our Ancestors' Lives. GenDisasters.com/oh/trains.

Haunted History of Columbus, Ohio. hauntedhistorycolumbus.blogspot.com.

INDEX

ABOUT THE AUTHOR

Ohio Train Disasters is Jane Ann Turzillo's third book for The History Press. Her other two are *Murder and Mayhem on Ohio's Rails* and *Wicked Women of Northeast Ohio.* As one of the original owners of a large Ohio weekly newspaper, she covered police and fire news and wrote a historical crime column. She also taught writing and literature at the college level. Many of her short stories and articles have been published in newspapers and magazines across the United States and Canada. One of her favorite jobs was working on publications in the public information office of an art museum. She has won several awards for fiction and nonfiction and is the author of two Arcadia historical nonfiction books on Bath

Courtesy of LBJ Photography.

Township, Ohio and Hudson, Ohio. When she isn't writing books or giving presentations on historical crimes, she writes a blog at darkheartwomen.

ABOUT THE AUTHOR

wordpress.com. She holds degrees in Criminal Justice Technology and Mass-Media Communication from The University of Akron. Her memberships include Mystery Writers of America, Sisters in Crime and National Federation of Press Women.